This book was awarded as part of the
Bridging Cultures Bookshelf: Muslim Journeys

Fifteenth-century map by Piri Reis of the coastline of Andalusia and the city of Granada. Photo ©The Walters Art Museum, Baltimore.

Presented by National Endowment for the Humanities in cooperation with American Library Association and Ali Vural Ak Center for Global Islamic Studies, George Mason University

Discover more about Muslim Journeys at bridgingcultures.neh.gov/muslimjourneys

NATIONAL ENDOWMENT FOR THE **Humanities** **ALA** American Library Association GEORGE **MASON** UNIVERSITY | Ali Vural Ak Center for Global Islamic Studies

Support for this program was provided by a grant from Carnegie Corporation of New York. Additional support for the arts and media components was provided by the Doris Duke Foundation for Islamic Art.

The Art of
Hajj

Venetia Porter

INTERLINK BOOKS
An imprint of Interlink Publishing Group, Inc.

First American edition published in 2012 by

INTERLINK BOOKS
An imprint of Interlink Publishing Group, Inc.
46 Crosby Street, Northampton, Massachusetts 01060
www.interlinkbooks.com

Library of Congress Cataloging-in-Publication Data available
ISBN 978-1-56656-884-5

Designed by Bobby Birchall, Bobby&Co.
Printed and bound in Italy

Opposite: A manuscript illustration of Mecca (detail). See fig. 50.

The papers used in this book are recyclable products made from
wood grown in well-managed forests and other controlled sources.
The manufacturing processes conform to the environmental
regulations of the country of origin.

To request our complete full-color catalog, please call us toll
free at **1-800-238-LINK**, visit our website at **www.interlinkbooks.com**,
or send us an e-mail: **info@interlinkbooks.com**

Contents

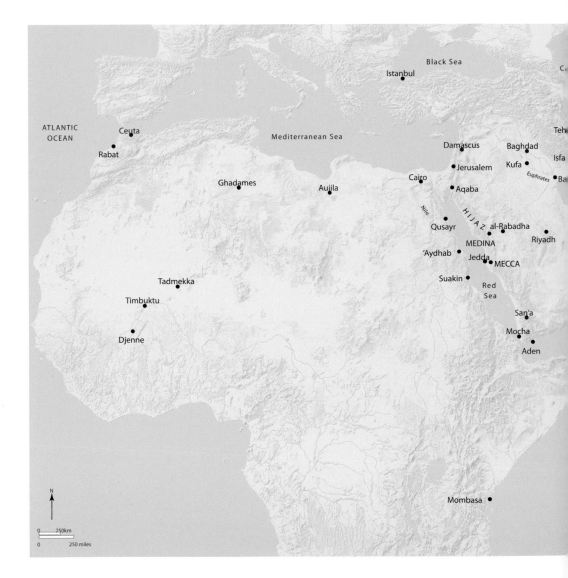

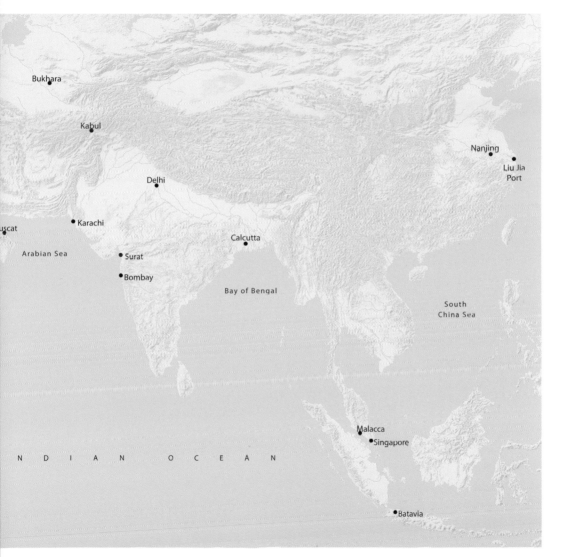

Bukhara

Kabul

Nanjing

Liu Jia
Port

Delhi

uscat

Karachi

Arabian Sea

Calcutta

Surat

Bombay

Bay of Bengal

South
China Sea

N D I A N O C E A N

Malacca

Singapore

Batavia

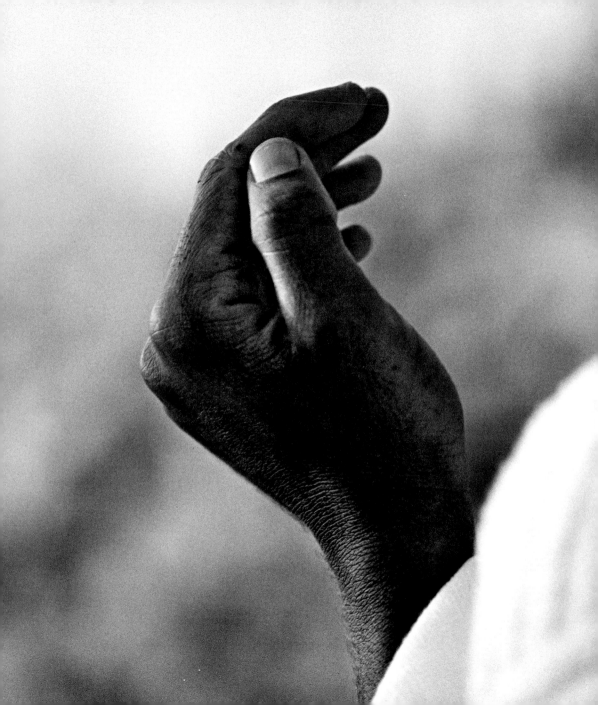

Introduction

Proclaim the Pilgrimage to mankind. They will come to you on foot and on every kind of swift mount, emerging from every deep recess.

Qur'an 22:27

Fig. 1
Hajj by Reem Al Faisal, 2003–5

Born in Jedda, Reem Al Faisal studied literature at King Saud University before pursuing a career in photography in France. She is fascinated by the Hajj, which she has photographed over a period of years:

'From the first day of the Hajj one is swept away by the sheer motion and size of it and you find yourself moving at another level of your consciousness. As you perform one ritual after the other you slowly discover the rhythm of the universe.'

Hajj is the annual pilgrimage to the sacred city of Mecca, known in Arabic as 'Makka al-Mukarrama' ('Mecca the Blessed'), and its environs. It is laid down in the Qur'an that at least once in their lives, if they are able, all Muslims must undertake this journey. An intensely personal experience as well as a collective public act, the Hajj is undertaken at a specific time of year, starting on the eighth day of Dhu'l-Hijja, the last month in the Muslim lunar calendar, and continuing for five days. Dressed in plain white garments, known as *ihram*, the Hajjis follow a sequence of rituals, each of which has particular symbolic meaning and resonance. Muslims have been going on Hajj since the seventh century. The Prophet Muhammad performed the only Hajj circumstances allowed him in 632, the year of his death. With him were just a few thousand Muslims, all from Arabia. Today, each year at least three million from all over the world make this spiritual journey.

At the heart of Mecca is the Ka'ba, situated within a sanctuary known as the *al-Masjid al-Haram* ('the Sacred Mosque'), or simply as *al-Haram* ('the Sanctuary'), which comprises a mosque and other buildings. The Ka'ba is a cube-shaped hollow structure, about eight metres square, made of granite. According to the Qur'an, it was built by the Prophet Abraham (Ibrahim) and his son Ishmael (Isma'il). Muslims also believe that as time passed most of their descendants abandoned the true religion for paganism. The revelation of Islam to the Prophet Muhammad in the seventh century revived monotheism and the original Abrahamic ideals. Embedded in one corner of the Ka'ba is the Black Stone, which pilgrims either touch or salute with a gesture before circling it seven times; *tawaf*, or circumambulation of the Ka'ba, is the first of the essential rites of the Hajj and also of the Umra, or lesser pilgrimage. According to some traditions, the Black Stone descended from Paradise pure white, but the sins of the descendants of Adam turned it black.

The rituals of the Hajj and visiting Mecca and Medina, the goal of a lifetime for Muslims, have inspired writers to recount the experience of their spiritual journeys and their reactions on reaching the holy cities. The Hajj has also inspired many artists and craftsmen, only some of whom have signed their works – for the most part they remain anonymous. Their skills can be seen in the objects highlighted in this book: colourful depictions and evocations of the holy places in manuscripts, Hajj certificates and tiles, and on the walls of houses; the instruments made to find the direction of Mecca; the glorious textiles offered to the two sanctuaries; the imaginative works by modern artists.

Author's Acknowledgements

This book is intended as a companion to the exhibition *Hajj: journey to the heart of Islam* and could not have been written without the help of a number of colleagues and friends. The following contributed advice on specific objects in their collections which have been generously lent to the exhibition: Charlotte Maury at the Louvre, Mina Moraitou and Anna Ballian at the Benaki Museum, Nahla Nassar from the Nasser D. Khalili Collection of Islamic Art and Colin Baker at the British Library. In addition I would like to thank Silke Ackermann at the British Museum who worked with me on the instruments for finding the direction of Mecca and Jan Just Witkam for his help on the Leiden University World map. I would also like to thank Peter Barber on the Gujarati chart, Farouk Yahya and Annabel Gallop on the Patani Dala'il al-Khayrat, Farhana Namman on the British Library Hajj certificate and also Syukri Zulfan, Salman Abdul Muthalib, Nina Swaep and Annabel Gallop who have all worked on different aspects of the Aceh drawing of the sanctuary at Mecca. For much guidance and advice generally I would like to thank James Allan and Tim Stanley. My greatest debt of all goes to Muhammad Isa Waley who kindly read through the manuscript and made many useful suggestions, and who provided beautiful translations from Persian of the poem by Sa'di 'On the effects of education' and the texts of Futuh al-Haramayn.

At the British Museum I would like to thank most warmly Qaisra Khan who has worked closely with me on the exhibition since the beginning; Nina Shandloff for the careful editing of the book, Bobby Birchall for the design, Melanie Morris for the production work, and Coralie Hepburn who has been a wonderfully encouraging and supportive editor. My final thanks go to Neil MacGregor whose initial vision and continuing encouragement have helped to make the work on this exhibition such a rewarding experience, and to my husband Charles and our daughters Emily and Rhiannon, whose love and support have sustained me throughout.

As regards the spellings of Arabic words, we have opted for simplicity. The only transliteration is for the letter 'ayn and the *hamza* where they occur in the middle of a word (as in Ka'ba or Qur'an). Dates are given in AD form. For the translations from the Qur'an, we have generally used the translation by M.A.S. Abdel Haleem.

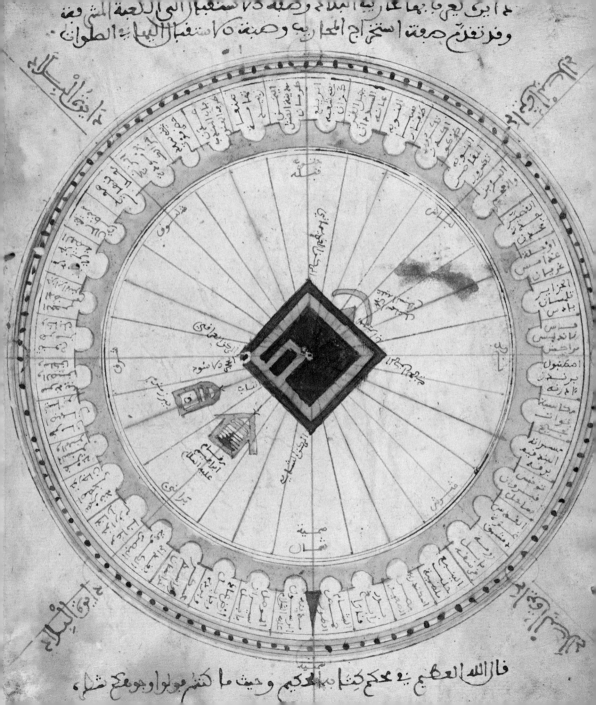

Chapter 1

Mecca: Centre of the World

Turn your faces in the direction of the Sacred Mosque: wherever you [the believers] may be, turn your faces to it.

Qur'an 2:144

Fig. 2
Sea atlas of Ahmad al-Sharafi al-Safaqusi (fol. 4b)

North Africa, dated 1571–2
Drawing on paper
26.8 x 20.7 cm
Bodleian Library, Oxford

This colourful chart exemplifies the notion of 'sacred geography' and may have been made as a souvenir for a ship's captain. In the centre are the Ka'ba and the other key features of the Meccan sanctuary, the Maqam Ibrahim and the well of Zamzam. Around the edge are the names of cities and regions, in groups of three within a mihrab niche. The maker came from Sfax in Tunisia, and the North African connection is further demonstrated by the use of the script known as Maghribi.

At first, Muslims faced Jerusalem in accordance with Jewish tradition. A revelation to the Prophet Muhammad then ordained that Muslims should face Mecca when they prayed. The sacred direction towards the Ka'ba is known as the *qibla*. For Muslims living close to Mecca, finding the *qibla* presented little problem. However, as the community spread beyond Arabia, determining the exact direction of the *qibla* became a major preoccupation. It soon became normal practice in mosques for the direction of prayer to be indicated by a niche known as a *mihrab*. At the same time, Muslim scholars developed procedures, charts and instruments for determining the *qibla*. Some depended on using the stars or other natural phenomena for guidance. Other, more complex techniques and instruments could be used at home or while travelling, perhaps across remote regions or else by sea. They were also applied when laying the foundations of a mosque. The introduction of the magnetic compass from China enabled the production of small instruments which when correctly oriented by means of a metal needle could indicate the *qibla* from a variety of locations.

11

Fig. 3
World map pasted into a copy
of the Tarih-i Hind-i Gharbi,
'History of the West-Indies'
(fol. 90b), a Turkish work on
the discovery of the Americas,
compiled in or before 1580 by
an anonymous Ottoman author

Manuscript on burnished European
paper, dated 1650
23.2 x 13.6 cm
Leiden University Library, Leiden

The projection of the world in which
the south rather than the north is
shown at the top is a convention
followed by Muslim geographers
originally inspired by the maps of the
ancient world. The seas and oceans
are painted in deep blue and major
cities such as Baghdad, Damascus
and Cairo are represented by tiny
architectural sketches. The legendary
'mountain of the moon' where the
palace of Alexander is said to have
stood is depicted as a red niche at
the top left. Placing the Ka'ba at
the very centre of a geographical
representation of the world as it
was then known takes this map into
the realm of sacred geography. The
Ka'ba is shown with its traditional
black cloth covering (kiswa), and
the belt (hizam), painted in gold.
Below is an arched niche suggesting
the mihrab in a mosque and
emphasizing that this is the
direction of prayer.

Fig. 4
Manual for calculating prayer times (fol. 13a) by Abd al-Rahman ibn Abdallah al-Tuluni al-Iskari, copied by Muhammad ibn Ibrahim al-Najahi al-Shafi'i, dated 1715

21.3 x 15.2 cm
Chester Beatty Library, Dublin

Performing the salat – the five daily prayers – is one of the five pillars of Islam. They comprise the morning prayer (fajr), the midday prayer (dhuhr), the afternoon prayer (asr), the prayer after sunset (maghrib) and the evening prayer (isha). To enable the correct times for these to be determined, an instrument known as a quadrant was developed by Muslim astronomers. Designed as a flat plate, it has a scale of ninety degrees along the curved edge with a plumb-line and bob suspended from the tip of the right angle. The quadrant could be used by the muwaqqit, who was in charge of fixing the times of the prayers in the larger mosques, or by an individual. This manuscript text explains how to calculate prayer times using a quadrant.

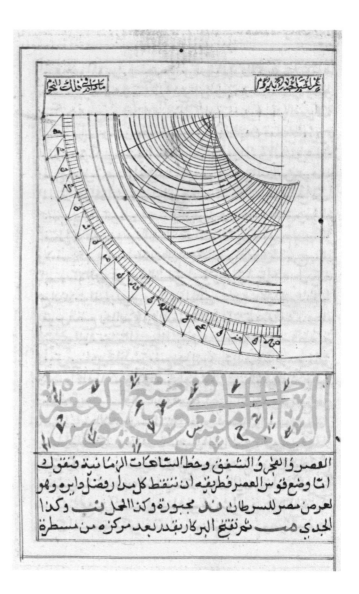

Fig. 5
Qibla indicator and sundial

Ottoman Turkey, 1582
Painted ivory
11 cm diameter
British Museum, London

This unusual instrument for finding the direction of Mecca (qibla) was made by Bayram ibn Ilyas, who has signed his name on the face of the instrument. The sail-shaped feature between the Ka'ba and the compass is a sundial that enables the user to find the time of the asr *(afternoon) prayer. It is calibrated in so-called 'unequal hours' – the length of daylight between sunrise and sunset divided into twelve parts whose duration changes over the course of the year. The innermost of the concentric circles is also laid out as a sundial, but indicates equal hours (as in most clocks and watches). The string-gnomon, which is attached to the tip of the metal pin and threaded through a hole in the ivory just below the compass, casts a shadow that allows both sundials to be used in conjunction. To do this the instrument is placed on a flat surface and rotated until the needle on the compass is correctly aligned in a north-south direction. When the metal pin points due north, then the string is properly aligned towards the North Pole and the sundial will indicate the correct time – but only for the latitude for which it was constructed.*

The seventy-two sectors around the rim contain the names of cities and regions in the Islamic world. This is not intended to be an accurate 'map' but an approximation, with places that are in the same region (and thus have roughly the same qibla) grouped together. To give an example, imagine the dial of a clock with numbers one to twelve around the outer rim. The foot of the metal pin is at 12 o'clock. The places listed between 12 o'clock and 3 are all roughly north-east of Mecca and so their qibla direction is south-west. To use the qibla indicator at a particular place, one would first identify that place in the list and its position in relation to the Ka'ba in the centre. Then one would align the instrument in a north-south direction with the help of the compass to determine the approximate direction of the Ka'ba.

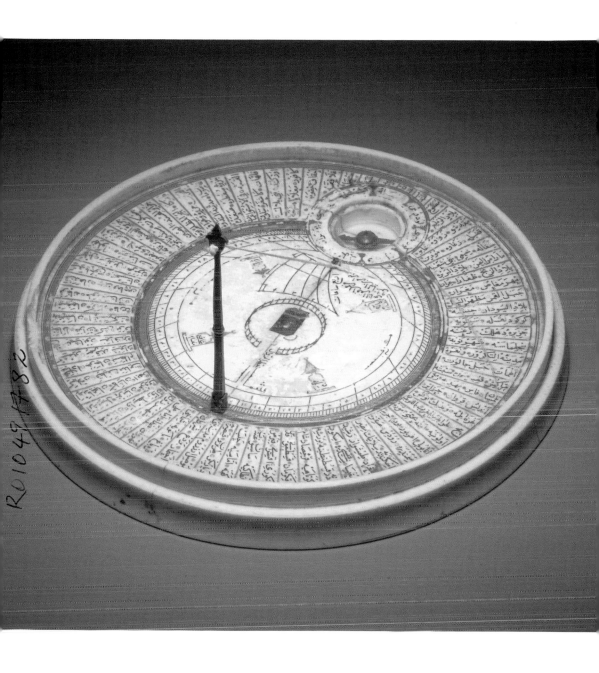

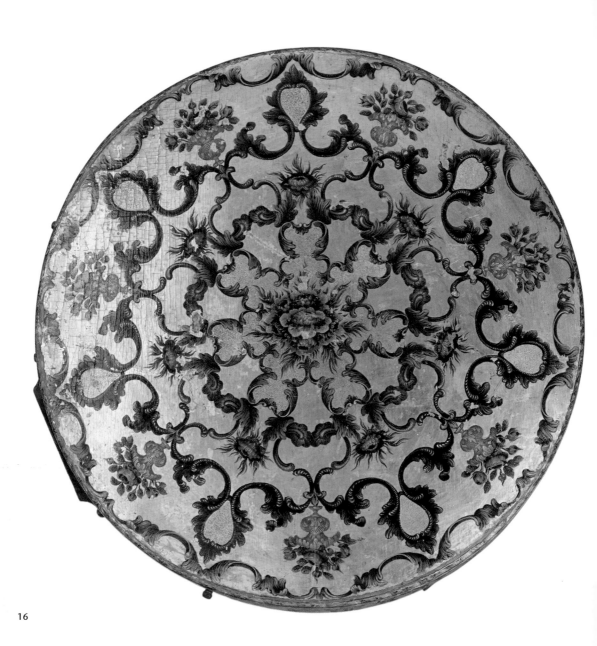

Fig. 6
Qibla indicator and compass

Dated 1738
Lacquered wood
30 cm diameter
Museum of Islamic Art, Cairo

*This instrument, encased within a
box, is one of a number made by an
Armenian named Bedros Barun for the
Ottoman grand vizier Yegen Mehmet
Pasha in the 1730s. Barun was an
interpreter for the Dutch Legation in
Istanbul. He combined a European
map with a compass and a pointer
towards Mecca, and a list of countries
and cities with their co-ordinates. On
the top of the box is a topographical
representation of the sanctuary at
Mecca itself, surrounded by the other
key locations within the enclosure.
Below, the text in Ottoman Turkish
explains how the compass should be
used. The outside of the instrument is
elegantly painted with colourful designs
in a baroque style typical of Ottoman
art of this period.*

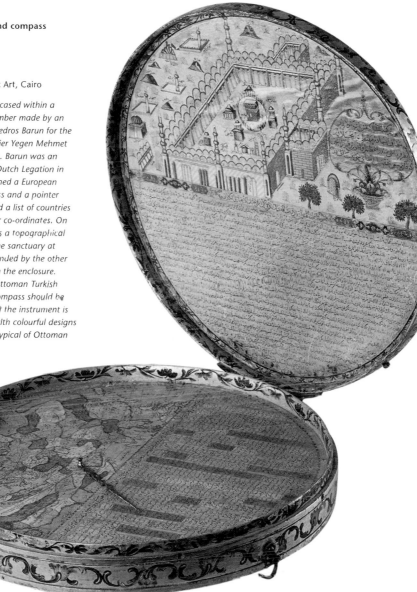

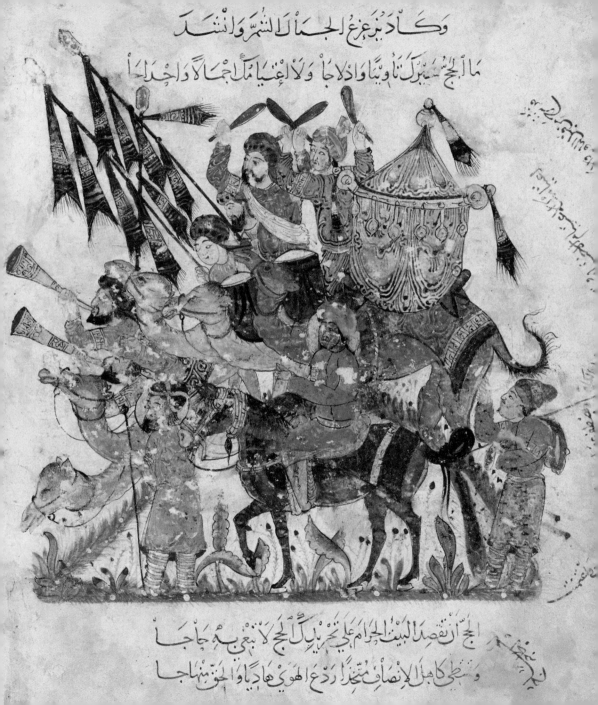

وكاد ينزع الجمال الشمر وانشد

ما الحج سيرك نيا وادلاجا ولا اعيا تمل اجمالا واجدا ا

الحج ان تقصد البيت الحرام على تحميل كل الحج لا يبغي به حاجا

وسطى كاهل الانصاف متخدا ردع الهوى هاديا والحق منهاجا

The Journey

I set out by myself with no companion to cheer me along or any caravan to join with, compelled by an overwhelming urge and a long held desire in my heart to visit those famous sanctuaries. So I confirmed my decision to leave everyone dear to me ... and flew from my home as birds desert their nests.
Ibn Battuta, 1325

Fig. 7
The Maqamat (Assemblies)
of al-Hariri (fol. 94b)

Baghdad, 1237
Opaque watercolour, ink
and gold on paper
39 x 34 cm
Bibliothèque Nationale de France,
Paris

This manuscript is one of the masterpieces of Arab painting. It was written and illustrated by the artist Yahya al-Wasiti, who came from the city of Wasit in Iraq. This folio depicts the caravan to Mecca setting off from Ramla in Palestine. The pilgrims carry banners and play trumpets and drums. One of the camels carries a yellow palanquin, the colour of the Mamluk mahmal.

From the furthest reaches of the Islamic world, from Timbuktu to China, pilgrims made the spiritual journey that was the ambition of a lifetime. Because Hajj must be performed at a designated time, for practical reasons pilgrims generally moved together in convoys. These were sometimes so great that they are described as cities on the move. Those travelling overland by camel or on foot congregated at various major cities such as Damascus in Syria or Cairo in Egypt. Pilgrims coming by sea would enter Arabia at the port of Jedda. In the past the journey to Mecca could be extremely dangerous: pilgrims often fell ill, they could be robbed on the way and become destitute. However, they did not fear dying on the journey as they believed that if they did so they would go to heaven with their sins erased. These journeys across land and sea are colourfully evoked in manuscripts and paintings.

Fig. 8
Kulliyyat (collected works) of
Sa'di (fol. 24b)

Shiraz, 1566
Opaque watercolour, ink
and gold on paper
40 x 28 cm
British Library, London

During the sixteenth century one of the
most important schools of painting and
book production flourished at Shiraz
in Iran under the patronage of the
Safavid Shah Tahmasp (1524–76) and
others. The exquisite paintings often
illustrated Persian poetry. This painting
features a convoy of pilgrims en route
to Mecca; some pilgrims ride camels or
horses, others are on foot. The wealthier
pilgrims are carried in elaborate
palanquins. They are observed by
onlookers who peek out from behind
the hills. The painting illustrates a story
from the Gulistan *or 'Rose Garden' of*
the celebrated sage and poet Sa'di of
Shiraz (d. 1292), who undoubtedly
went himself on Hajj. It comes from
chapter 7, 'On the effects of education':

'One year a dispute broke out amongst
the hajjis *who were travelling on*
foot, and I too was going on foot. We
"dispensed justice" fully indulging our
viciousness and quarrelsomeness, by
means of an angry shouting match. I
heard someone who was sitting in a
camel litter say to the man next to him:
"How strange! If a pawn travels the
length of the chessboard it becomes a
queen, and so becomes better; but these
travellers to Hajj on foot have crossed
the desert – and become worse".

"Tell the backbiting pilgrim on my behalf –
him who injures people by slandering them –
'You're no pilgrim! Your camel's the real one:
poor creature, he eats thorns and carries loads'."
(Translated by Muhammad Isa Waley)

20

وفزین میشود دسپاه کان حاج با دیه سربردند و بکرشاند

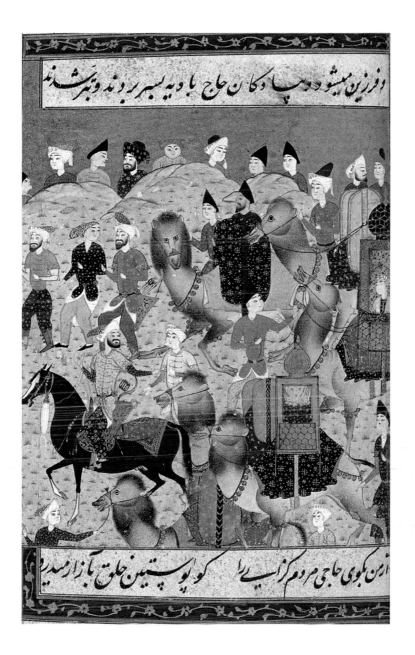

کوبوستین جلوف باز ارمیدر
ازمن کبوی حاجی مردم کزانبی یرا

Fig. 9
The Maqamat (Assemblies)
of al-Hariri (fol. 95a)

Baghdad, 1237
Opaque watercolour,
ink and gold on paper
39 x 34 cm
Bibliothèque Nationale de France,
Paris

The Maqamat, *meaning*
'assemblies', are a genre of Arabic
literature in rhymed prose. They
centre around a narrator, the
merchant al-Harith, and a roguish
figure called Abu Zayd. Here, in the
thirty-first Maqama, *al-Harith joins*
a Hajj-bound caravan. At one of the
stops he hears the voice of Abu Zayd,
eloquently haranguing the pilgrims.
Abu Zayd is depicted here standing
on a hillock, with the pilgrims
gathered around him.

'Oh you company of pilgrims …
do you comprehend what you are
about to face … and what you
are undertaking so boldly? Do you
imagine that the Hajj is the choosing
of saddle beasts, the traversing of
stations? … that piety is the tucking
up of sleeves, the emaciating of
bodies, the separation of children,
the getting far from your native
place? No by Allah … it is the
sincerity of purpose for making for
that building there, and the purity of
submission along with the fervour of
devotion, the mending of dealings,
before working the doughty camels.'
(Translated by A. Shah)

وَإِنْ تَوَاسِي مَا أُوِيتَ مَقْدِرَةٌ مِنْ مِدَّكَفًا الْجَدَّ وَالْمِزَاجَا

فَهَذِهِ إِنْ جَوَّتَاجِهْ كَمُلَتْ وَإِنْ خَلَا الْحَجُّ مِنْهَا كَانَ خِدَاجَا

حَسِبُ الَّذِينَ عِبْنَا الْنَّهَرَ غُرْسُولَ وَمَا جَنَوْا لَفُوا كُلَّا وَإِرَعَاجَا

وَأَنَّهُمْ حُرِمُوا أَجْرًا وَمَحْمِدَةً وَالْحَوْا عِرْضَهُمْ مِنْ عَابَ أَوْهَابَا

Fig. 10
Catalan atlas, 1375

Painted vellum, one of six leaves
(panel 6)
65 x 50 cm (each leaf)
Bibliothèque Nationale de France,
Paris

*This map is one of the great
masterpieces of the medieval world.
It is a nautical atlas combined with
historical, ethnographical, botanical
and zoological information in the
form of colourful illustrations and
texts. It is part of a tradition of
medieval world maps known as
mappae mundi and is attributed to
the Majorcan mapmaker Abraham
Cresques. Such maps were made
as gifts for great libraries and this
example may have been presented to
Charles V of France in about 1380.*

*The detail illustrated is from a
section on Africa. It shows the King
of Mali, Mansa Musa, seated on his
throne holding a staff and a golden
globe. Mansa Musa famously went
on Hajj in 1324. He left from his
capital Timbuktu, a great medieval
city of learning, and journeyed
in great style across the desert to
Cairo. He is said to have travelled on
horseback preceded by 500 slaves,
each carrying a staff of gold, and
with a retinue of 60,000 servants.
He carried with him so much gold
and such was his generosity that he
is said to have flooded the market
with coins, causing the Egyptian
economy to falter for about ten
years.*

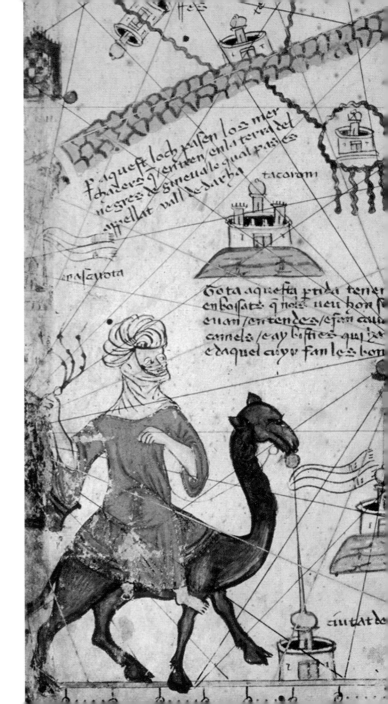

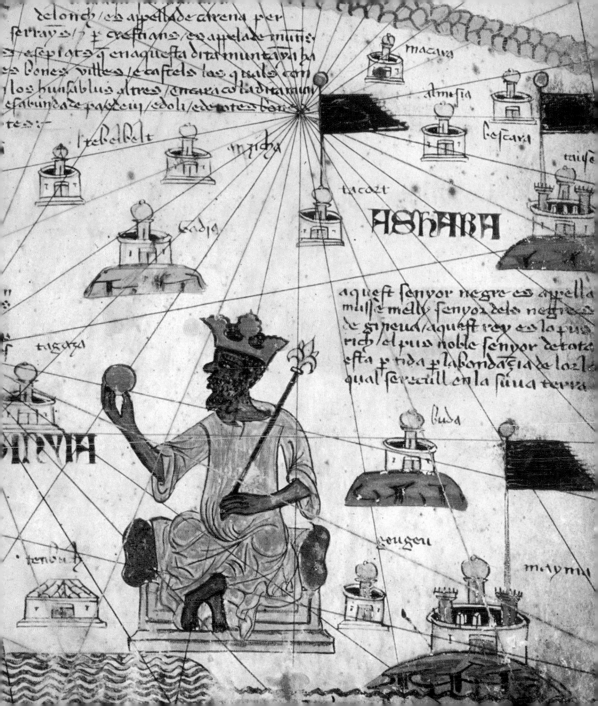

Fig. 11
**Ceremonial delivery of the
Imperial Sürre to the Captain
of the Procession**

Ignace de Mouradgea d'Ohsson,
*Tableau Général de l'Empire
Ottoman*, Paris, 1787 (pl. 46)
51 x 34 cm
Arcadian Library, London

*In 1517 the Ottomans, with their
capital at Istanbul, took over Egypt
and Syria from the Mamluks, who
had long enjoyed lordship of the
Hijaz and the holy cities of Mecca
and Medina. The Ottomans took
their Hajj responsibilities extremely
seriously. Every year they organized
the great caravan to Mecca known
as the* Sürre *(purse). This engraving
shows one of the ceremonies that
took place with great pomp at
Topkapi Palace before departure.
The Sultan is seated on his throne
in the pavilion and the procession
stands before him. On the left the
chief stableman holds the bridle of
the camel bearing the ceremonial
palanquin known as the* mahmal.
*The Ottoman sultan never went on
Hajj for security reasons, but the*
mahmal *symbolized his authority*

*in a tradition going back to the
Mamluk sultan Baybars (1260–77).
A second reserve camel can be seen
on the right. These camels were
simply part of the ceremonial and did
not actually go to Mecca. A group of
official figures on the right carry the
documents that are to be delivered
to the* Sürre *captain, the leader of
the Hajj caravan.*

The Tableau Général *was a
remarkable endeavour. It was a
two-volume compendium of the
history and customs of the Ottomans
written by Ignace de Mouradgea
d'Ohsson, an Armenian banker living
in Istanbul, and lavishly illustrated
with engravings based on the
works by a large number of artists
from both within and outside the
Ottoman empire.*

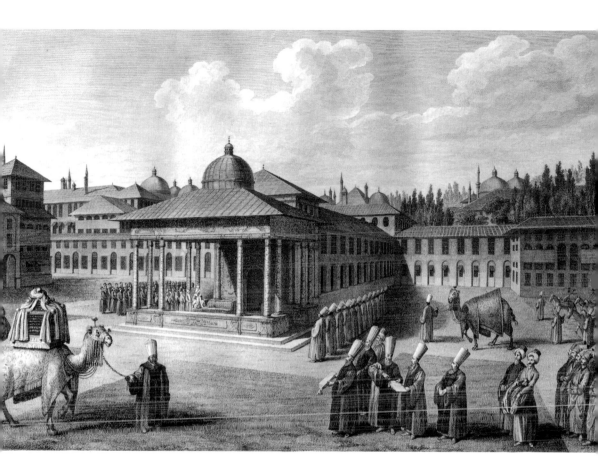

27

Fig. 12
Costumes Turcs (vol. I, fol. 125)

Ottoman Turkey, *c.*1790
Watercolour on paper
22 x 37 cm
British Museum, London

Money was carried with the Sürre caravan to Mecca to pay for services along the route and gifts to the holy sanctuaries and the people of Mecca. These would include Qur'ans, gold coins and objects such as candlesticks. This watercolour is from an album of drawings formerly in the collection of Heinrich Friedrich von Diez. It shows a white mule draped with bells and bearing gifts. The structure on its back echoes the form of the mahmal *and is decorated with plumed sticks. This drawing also appears in the form of an engraving in d'Ohsson's* Tableau Général de l'Empire Ottoman *(see fig. 11).*

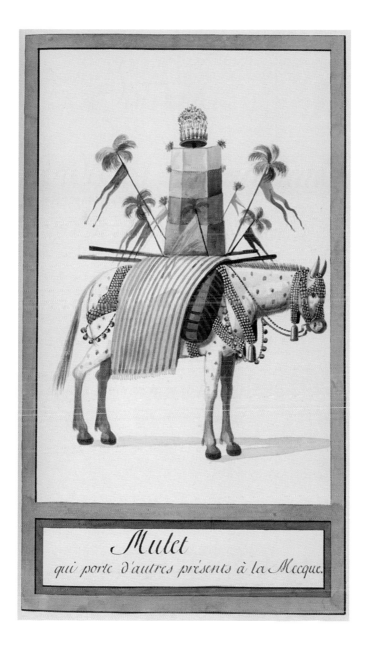

Mulet
qui porte d'autres présents à la Mecque.

Fig. 13
The Amir al-Hajj (caravan commander), Abdi Pasha, on his way from Mecca to Medina, from Anis al-Hujjaj (The Pilgrim's Companion) by Safi ibn Vali (fol. 18b)

India, possibly Gujarat,
c.1677–80
Opaque watercolour, ink
and gold on paper
33 x 23.2 cm
Nasser D. Khalili Collection
of Islamic Art

This painting is one of a number of illustrations (see figs 14 and 35) from a pilgrims' manual written during the year-long Hajj undertaken by its author Safi ibn Vali in 1676. Besides giving advice about the journey by ship and the rituals of Hajj, he describes the groups of pilgrims he saw en route coming from different parts of the world. Some of the paintings have annotations, as in this example. Here we see Abdi Pasha, the Amir al-Hajj, dressed in gold on a horse identified in an inscription above. He was in charge of the Hajj caravan of that year from Egypt, which here is depicted on its way to Medina. He is escorting the mahmal, *the sacred palanquin that represented the authority of the Ottoman sultan, carried by the camel at the top of the painting. There is also a Qur'an on a stand, one of a number of gifts for the sanctuary. The convoy is escorted by soldiers armed with rifles as the caravans were often attacked and plundered. The artist is unknown but the style is typically Mughal, particularly in the features and dress of the people.*

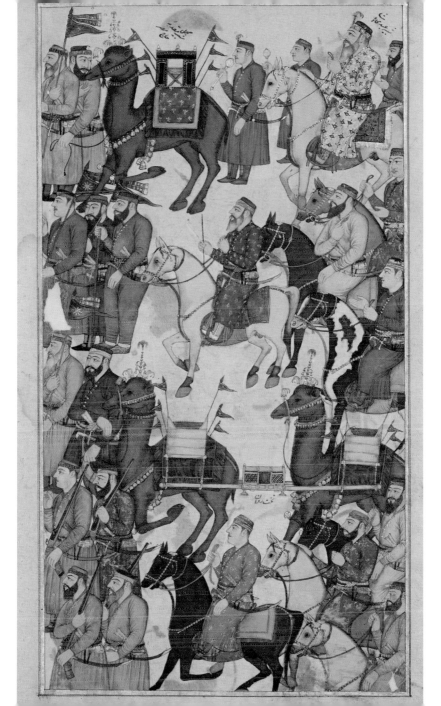

31

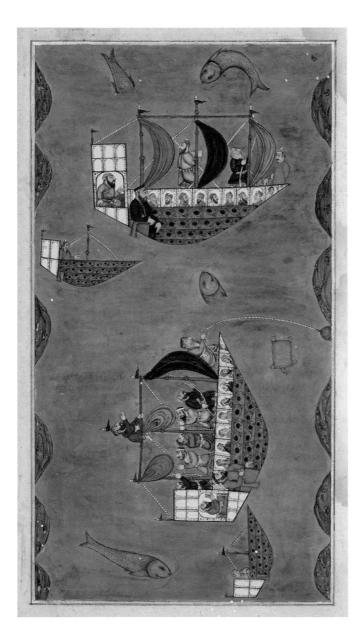

Fig. 14
Crossing the Sea of Oman,
from Anis al-Hujjaj (The Pilgrim's
Companion) by Safi ibn Vali
(fol. 3b)

India, possibly Gujarat,
c.1677–80
Opaque watercolour, ink
and gold on paper
33 x 23.2 cm
Nasser D. Khalili Collection
of Islamic Art

In this painting the ships having
traversed the Indian Ocean are
now crossing the Arabian Sea (here
called the Sea of Oman) on their
way to the Red Sea and up to Jedda.
Safi ibn Vali advises pilgrims to be
careful in their choice of ships and
to make sure that the captain does
not take on too many passengers.
They are travelling in ocean-going
dhows in convoy. The smaller boats
are perhaps there to guide them. In
this lively and engaging composition
they are close to the shore and the
boats face in different directions,
the sailors busy on deck with the
sails. Fish leap out of the water and
a sea turtle is paddling on the right.
During the Mughal period every year
some 15,000 pilgrims went to Mecca
on Hajj.

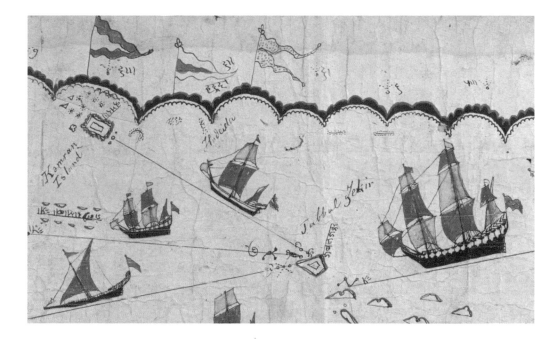

Fig. 15
Chart of the Red Sea
and Gulf of Aden (detail)

Gujarat, c.1835
Opaque watercolour and ink
on paper
24.1 x 195.6 cm
Royal Geographical Society, London

This chart drawn up by a Gujarati pilot or sea captain accurately represents the Gulf of Aden and the Red Sea. As in the painting from the Anis al-Hujjaj (opposite), the coast is drawn as a series of curves. Key places that would have been of interest to sailors including islands and reefs as well as flags of local rulers are annotated in Gujarati and Hindi, with some places noted in English such as Kamaran

Island. Different types of ships with colourful red and yellow sails are shown sailing along marked directional lines. It is likely that this map was used by ships transporting pilgrims to Mecca for Hajj. Depending on the season, the Red Sea could be notoriously difficult to navigate and Jedda had sometimes to be reached by local rather than ocean-going vessels.

This map was presented to Sir Alexander Burnes, a distinguished linguist and scholar who served in the Government of India, by a pilot in Kutch in western India where Burnes had been appointed assistant to the political agent in 1829.

33

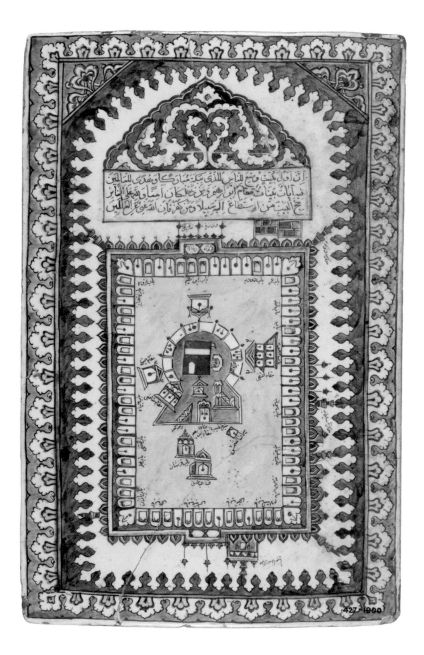

34

Mecca: The Blessed City

'I have made some of my offspring to dwell in a valley without cultivation by Your Sacred House'
Qur'an 14:37

Fig. 16
Tile depicting the Meccan sanctuary

Ottoman Turkey,
mid-17th century
Stonepaste, underglaze painted
61 x 38 cm
Victoria and Albert Museum,
London

This colourful tile depicting the Haram at Mecca is a product of the ceramic workshops at Iznik (or perhaps Kutahya) which also produced tiles of Medina (see fig. 48). The arch at the top decorated with Chinese cloud bands contains the verse from the Qur'an that clearly states the role and importance of the Ka'ba: 'The first House [of worship] appointed for mankind was that at Bakka [the old name for Mecca]: full of blessings and guidance for all kinds of beings. In it are signs manifest: the Station of Abraham; whoever enters it attains security. Pilgrimage to the House is a duty mankind owes to God, whoever is able to make their way there.' (Qur'an 3:96–7)

Mecca, where the Prophet Muhammad was born in AD 570, is situated in present-day Saudi Arabia, within a barren landscape in the mountainous region known as the Hijaz. It owes its existence to a sacred shrine that developed around the well of Zamzam. For centuries before the coming of Islam, the well, the Ka'ba and the surrounding Haram or sanctuary were controlled by a succession of nomadic tribes. The site became the main focus of pilgrimage for people across Arabia, and violence was prohibited there. Mecca also became an important centre of trade on the route between southern Arabia and the Mediterranean. With the coming of Islam the Haram became firmly rooted as the focus of the new religion and the direction towards which Muslims prayed.

Today the sanctuary covers an approximate area of 400,000 square metres and can accommodate up to one million people. At the centre is the Ka'ba, with the Black Stone built into the south eastern corner. Around the Ka'ba are a number of other sites of religious significance, including the Maqam Ibrahim and the well of Zamzam. Depictions of the Haram take a number of different forms, but the most popular is a two-dimensional diagram found on tiles and Hajj certificates, with labels in Arabic script identifying key places. Other illustrations combine the plan with a bird's-eye view showing architectural detail.

Fig. 17
Bird's-eye view of Mecca

Vienna, 1803
Engraving by Carl Ponheimer
49.7 x 88.3 cm
British Museum, London

*This panorama of Mecca was
drawn by the Austrian orientalist
Andreus Magnus Hunglinger, who
accompanied Constantine Ludolf,
minister of the King of the Two
Sicilies, to Istanbul. He based the
panorama on an illustration in
Mouradgea d'Ohsson's* Tableau
Général de l'Empire Ottoman
*(see fig. 11). The scene shows
pilgrims wending their way in a
long caravan across the desert
and pouring into the sanctuary in
their thousands. Designed to be
informative, it contains a key to sixty
numbered locations in and around
the sanctuary. Neither d'Ohsson
nor his engravers actually went to
Mecca but would have based the
description and drawing on existing
illustrations and the accounts of
Ottoman pilgrims.*

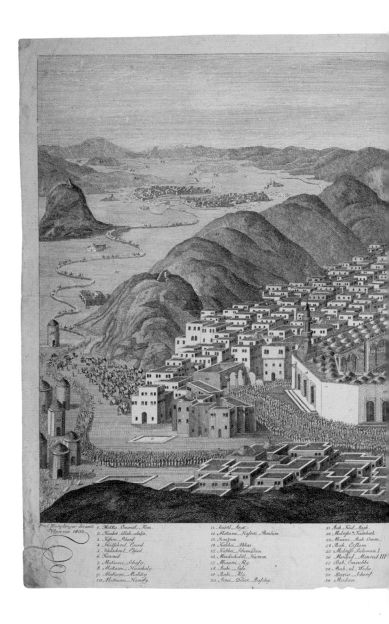

36

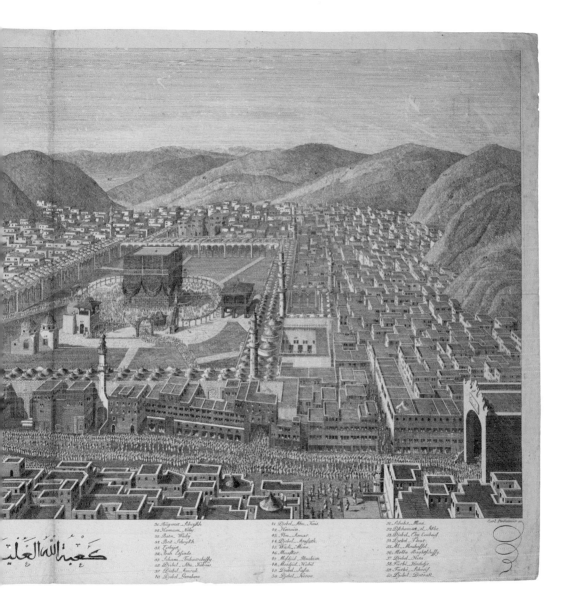

31 Rögmet Scheykh.
32 Hamam Neby.
33 Batn Wâdy.
34 Beit Scheykh.
35 Tarbyat.
36 Jvah Esfrade.
37 Scham Tschawuschly.
38 Djebel Abu Kobeis.
39 Djebel Auvrak.
40 Djebel Geraham.

41 Djebel Abu Kais.
42 Honain.
43 Ibn Amvar.
44 Djebel Arafath.
45 Wâdy Mina.
46 Musdhet.
47 Meddjel Strukism.
48 Meddjel Hiobel.
49 Djebel Safa.
50 Djebel Kerva.

51 Schekt Mina.
52 Djchemret el Abbe.
53 Djebel Oize Combaid.
54 Djebel Thur.
55 Al Machaffel.
56 Molla Basjtofschifty.
57 Djebel Hina.
58 Turbé Hadidje.
59 Turbé Scherif.
60 Djebel Dozvak.

Carl Fiedanier sc.

كعبة الله العليا

37

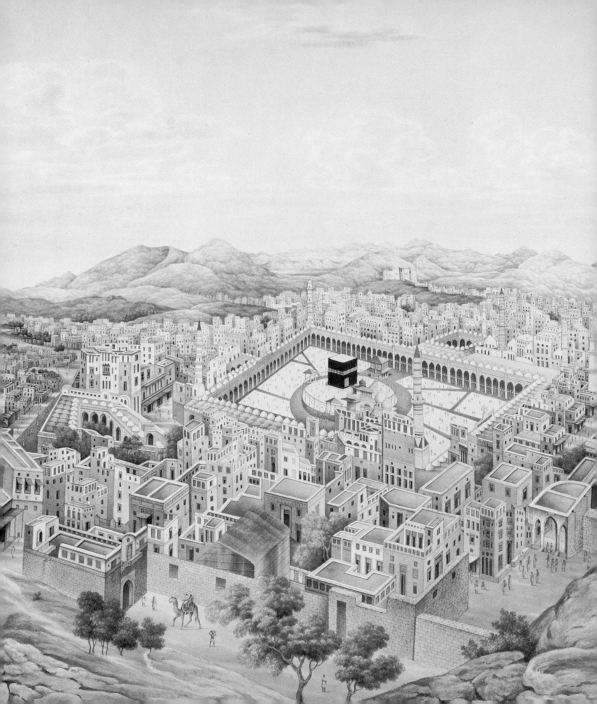

**Panoramic view of Mecca (detail)
by Muhammad Abdallah, c.1845**

Opaque watercolour and
ink on paper
62.8 x 88 cm
Nasser D. Khalili Collection
of Islamic Art

*This view of Mecca was
commissioned by the Sharif of Mecca
(Muhammad ibn Abd al-Mu'min
(1827–51). The cartographer
Muhammad Abdallah is described
in the inscription as 'cartographer
of Delhi', and his grandfather
Mazar Ali Khan was court painter
to the Mughul ruler Bahadur Shah
II (1837–58). This panorama
combines a detailed plan of the
city with a bird's-eye view of about
sixty degrees. Muhammad Abdallah
must have resided in Mecca. Richard
Burton, who visited the holy cities
in disguise in 1853, remarked that
'some Indians support themselves
by depicting the holy shrines; their
works are a truly Oriental mixture of
ground plan and elevation, drawn
with pen and ink, and brightened
with the most vivid colours …'*

39

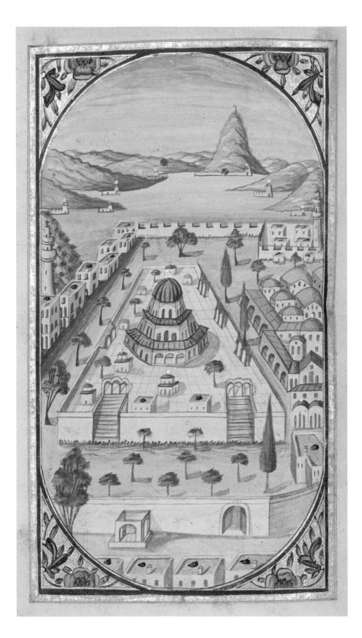

Fig. 19
Bahjat al-manazil (The joy of stages), by Mehmed Edib (fol. 219b)

Dated 31 August 1790
Opaque watercolour, ink
and gold on paper
19.9 x 13 cm
Chester Beatty Library, Dublin

This topographical illustration of Jerusalem accompanies the text of Mehmed Edib (al-Hajj Muhammad Adib Afandi ibn Muhammad Darvish), an Ottoman judge from Candia in Crete who travelled from Istanbul to Mecca in 1779 and wrote an extensive description of his journey and the places where he stopped. The painting, a somewhat fanciful representation, accompanies a section at the end of the book which describes Jerusalem and its sanctuaries. Before the revelation came directing them to pray towards Mecca, Muslims had prayed towards Jerusalem, the third most sacred city for Muslims after Mecca and Medina. The view is looking east. At the centre of the painting is the Dome of the Rock from where the Prophet Muhammad is believed to have made his 'night Ascension' (mir'aj), with the Masjid al-Aqsa to the right.

Fig. 20
Drawing of *al-Masjid al-Haram* and the Ka'ba

Chao Jin Tu Ji, the travelogue of Ma Fuchu, China, dated 1861
Woodblock on rice paper
15 x 26.5 cm
Aga Khan Collection, Geneva

Ma Fuchu (d. 1863) was an eminent scholar of Islam and Sino-Muslim philosophy and the author of some thirty-five books written in Arabic and Chinese ranging from metaphysics to history. He also translated the Qur'an. This simply drawn illustration is from the account of his journey from China to Mecca. Originally from Yunnan, he travelled with a group of Muslim merchants and began his long journey first overland, then by riverboat to Rangoon and then by steamship to Jedda, performing the Hajj in 1841

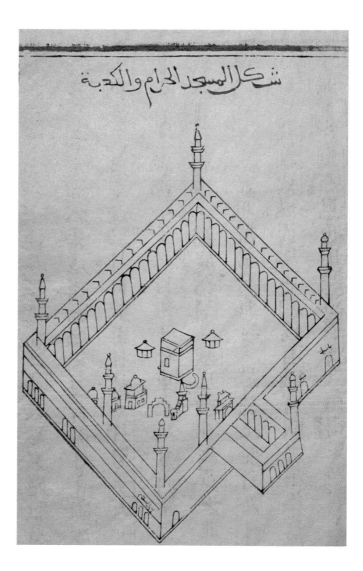

Fig. 21

Tile panel depicting the Meccan sanctuary

Ottoman Turkey, mid-17th century
Stonepaste, underglaze painted
73 x 49.5 cm
Benaki Museum, Athens

*The sanctuary at Mecca is drawn
over a panel of six polychrome
tiles. This is one of a series of such
renditions in tilework made in the
seventeenth and eighteenth centuries
which were placed in mosques
or in houses or palaces, perhaps
to commemorate an individual's
Hajj. The most important centre of
Turkish tile production was at Iznik,
but such depictions, both single
tiles and large tile panels, were
also made at other ceramic centres
such as Kütahya and later in the
eighteenth century at Istanbul at
the workshops of Tekfur Saray. This
example shows the monuments in a
more three-dimensional manner than
the Victoria and Albert Museum tile
(fig. 16). The Ka'ba is realistically
cube-shaped and the four schools
of Islamic law are domed structures
on the edge of the sanctuary circle,
with the pulpit of the Prophet on the
right and the well of Zamzam on the
left. There are hanging lamps in the
arcades and the tall minarets have
almost tulip-shaped crescents. At
the top of the panel is a verse by
the Ottoman poet Süleyman Nahifi
(d. 1739): 'Whoever has the fortune
to visit the Ka'ba, God forgives
him and whoever is invited to the
House is for certain the beloved.'
(Translated by Charlotte Maury)*

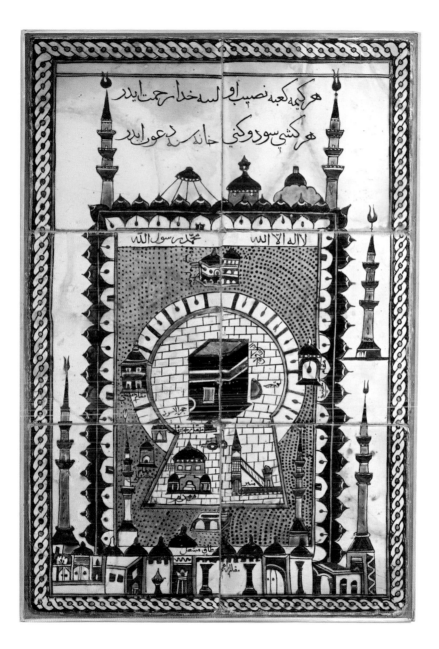

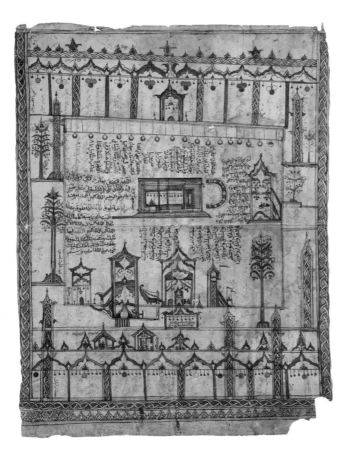

Fig. 23
The sanctuary at Mecca

Probably Mecca, 17th–18th century
Opaque watercolour, ink, silver and
gold on paper
64.7 x 47.5 cm
Nasser D. Khalili Collection of
Islamic Art

*Schematized depictions of the sanctuary
at Mecca are based on prototypes
that go back at least to the thirteenth
century. They first appear on illustrated
documents known as Hajj certificates.
These were often made in the form
of scrolls (see fig. 34) and include
depictions of Mecca, Medina and
Jerusalem. They attest that a believer
has undertaken the Hajj or that it has
been performed for them by someone
else. This colourful and beautifully
composed painting is a section from
such a certificate, probably made by
Indian craftsmen residing in Mecca
who may have made certificates and
other pilgrim guide books as souvenir
items for pilgrims. Features such as the
shapes of the domes clearly betray
Indian influence.*

Fig. 22
The sanctuary at Mecca

Aceh, Indonesia, late 19th century
Coloured inks and pen on paper
42.5 x 32.5 cm
Tropenmuseum, Amsterdam

*This unusual depiction of the sanctuary
at Mecca was made by an artist in
Aceh, Sumatra, and its decorative
features, the shape of the arches and
other details are Indonesian in style.*

*It is likely to have been made as a
guide for Hajjis, as each location
is clearly marked in Malay and
Arabic indicating which rite is to be
performed at each place. There are
three elegantly drawn lamps, each
described as the 'stand for the golden
light', as well as the usual features
including the Maqam Ibrahim, the well
of Zamzam, the arcades with their
hanging lamps and the four slender
minarets. Instructions are provided for*

*the specific prayers to be recited when
passing in tawaf (circumambulation)
the three corners of the Ka'ba, known
as the Yemeni, Syrian and Iraqi
corners, which represent the parts of
the Ka'ba that Muslims living in those
respective lands face when praying.
A text on the back states that it was
made for Teungku Imam Beutong
and was brought back from Aceh by
C.J.A. Haakman, a Dutch seaman
stationed there.*

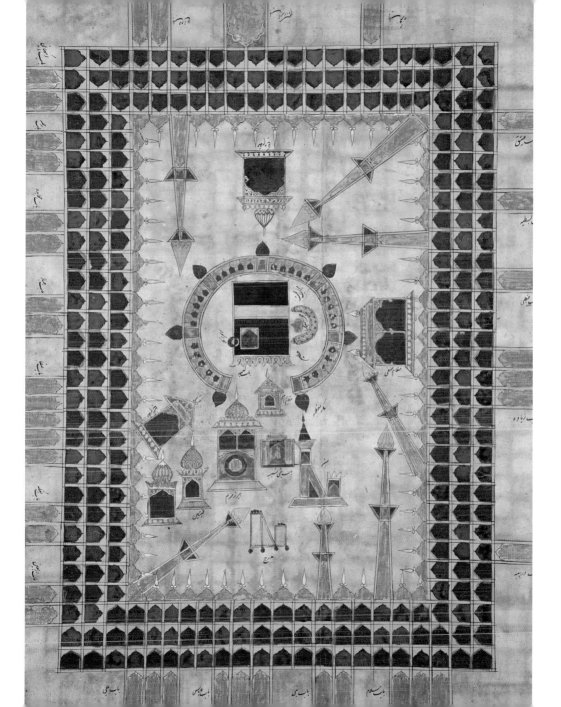

Fig. 24
Kiswa for a *mahmal*

Cairo, c.1867–76
Red silk, with green and dark
cream silk appliqués, embroidered
with silver and silver-gilt wire,
on a wooden frame
400 cm high (including finial
and fringe)
Nasser D. Khalili Collection of
Islamic Art

The mahmal, *a ceremonial
palanquin carried on a camel,
was the centrepiece of the pilgrim
caravan. It symbolized the authority
of the sultan over the holy places
and was first sent by the Mamluk
sultan of Egypt, Baybars (1260–77).
Carried with it were the textiles
made for the Ka'ba, which were also
produced in Egypt. Even after the
conquest of Egypt by the Ottomans
in 1517, a* mahmal *continued to be
sent from Cairo along with another
from Damascus. This magnificent
example, described in the inscription
as a* kiswa *(robe) for a* mahmal,
*was made in Egypt and bears the
embroidered monogram, the* tughra,
*of Sultan Abd al-Aziz (1861–76). On
the sides is the name of Isma'il, the
Khedive or ruler of Egypt (1863–79),
who received his title from Sultan
Abd al-Aziz in 1867 and presented
this* mahmal *to be taken on Hajj.
The 'Throne Verse' from the Qur'an
(2:255) is inscribed in sections all
the way around. The tradition of
sending the* mahmal *from Egypt
continued until 1926.*

*Great pomp and ceremony
surrounded the departure of the
Hajj caravans. Before setting off,
the* mahmal *would be paraded
around Cairo where people lined
the streets to see the magnificent
spectacle. Once on the road, the red
silk would be taken off or covered to
prevent it being damaged. Unlike the
textiles which remained in Mecca,
the* mahmal *came back with the
returning pilgrims ready for the
following year.*

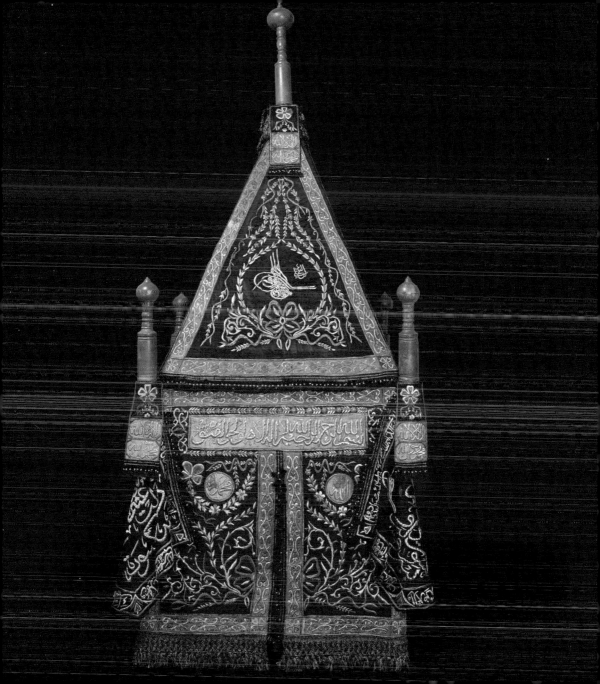

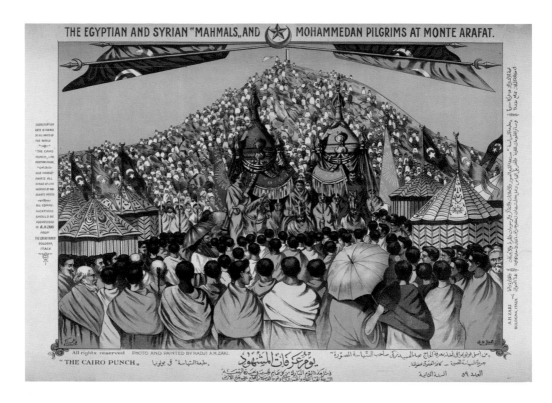

Fig. 25
'The Egyptian and Syrian
Mahmals and Mohammedan
Pilgrims at Arafat'

Popular print (painted photograph), *The Cairo Punch*, Cairo, early 20th century
48.8 x 69.5 cm
British Museum, London

This print and the one on the opposite page were produced for The Cairo Punch (al-Siyasa al-musawwara), *which published between 1910 and 1932 a series of prints representing major events in the Middle East. Hajj and the holy cities were popular subjects for illustration. Here the Egyptian and Syrian mahmals, having arrived from Cairo and Damascus, are standing on the slopes of Jabal al-Rahma ('The Mount of Mercy') on the plain of Arafat, surrounded by pilgrims from all over the world. Standing at Arafat is the central ritual of Hajj. It was here that the Prophet Muhammad gave the Farewell Sermon in 632, during the only Hajj that circumstances allowed hin to perform. Every pilgrim must be standing at this place on the ninth of the month of Dhu'l-Hijja or their Hajj will be deemed invalid.*

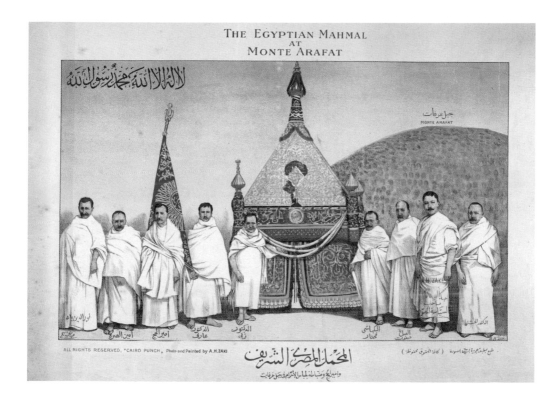

THE EGYPTIAN MAHMAL
AT
MONTE ARAFAT

Fig. 26
'The Egyptian Mahmal at Monte Arafat'

Popular print (painted photograph), *The Cairo Punch*, Cairo, early 20th century
48.8 x 69.5 cm
British Museum, London

In this scene a group of hajjis in ihram stand in front of the mahmal *at Arafat. On the left in front of the flag stands the Amir al-Hajj, with other named officials and doctors standing on either side of the* mahmal. *It is similar in style to the one shown in fig. 24. This print may be based on a photograph by one of the photographers of Hajj such as Abdullah Sa'udi, who performed Hajj in 1904 and 1908. Sa'udi describes how the* mahmal *was put on a train from Cairo as far as Suez, where it was placed on a boat and taken down to Jedda.*

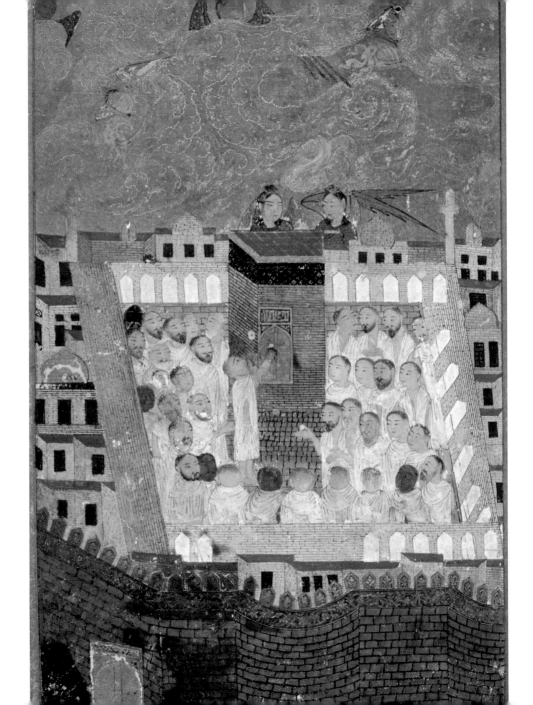

Chapter 4

Ritual and prayer

Fig. 27
'View of Mecca and Pilgrims'
from the Miscellany of Iskandar
Sultan (fol. 363a)

Shiraz, Southern Iran, 1410–11
Opaque watercolour, ink
and gold on paper
18.1 x 12.5 cm
British Library, London

This painting (part of a double-page illustration) was produced at the court of the great patron of the arts Iskandar Sultan at Shiraz. A dense throng of pilgrims in ihram circumambulate the Ka'ba, and one reaches up to the door. The sanctuary and the rest of the city are enclosed behind a high brick wall. The sky is painted with swirling gold clouds within which are angels, two of whom hover over the Ka'ba.

The rituals of Hajj take place in and around Mecca over a period of five days between the eighth and the twelfth days of Dhu'l-Hijja – the twelfth month of the Muslim calendar. In *tawaf*, the first of the rituals of Hajj, pilgrims walk anti-clockwise around the Ka'ba seven times, as can be seen in fig. 27. This tradition goes back to the time of Abraham. Once he and his son Ishmael had finished rebuilding the Ka'ba and had set the Black Stone in its corner, they circled it seven times. The next ritual is known as *sa'i* or 'running'. This commemorates Hagar's search for water after her husband, the Prophet Abraham, at God's command left her in the desert as a test of faith. Having exhausted their provisions, Hagar desperately ran seven times between the hills of Safa and Marwa searching for water. Returning to her son Ishmael, she found that a spring of water had miraculously gushed out of the ground. This is known as the well of Zamzam. The other rituals of Hajj take place outside Mecca, at Mina, Arafat and Muzdalifa. The third day of Hajj (the tenth of Dhu'l-Hijja) is the day of Eid al-Adha – the Festival of the Sacrifice. A sheep, goat, camel or cow is sacrificed and its meat distributed to the poor. Celebrated by Muslims around the world, Eid al-Adha commemorates Abraham's offering of his son Ishmael as a sacrifice to God. After pilgrims have cut or shaved their hair and performed *tawaf* again they may change out of their *ihram* clothes. In the following pages, paintings from a variety of sources, including Hajj certificates and pilgrimage guides, depict pilgrims performing some of the rituals of Hajj and the locations where they take place. A modern photograph indicates the scale of Hajj today.

Fig. 28
In God's Eye
by Shadia Alem, 2010

Shadia Alem was born in Mecca and her family have been involved with the care of the sanctuary and the Hajj for generations. She herself inherited the title of mutawwif, *one who hosts and guides the pilgrims on Hajj. She is a painter, installation artist and photographer, and with her sister Raja represented Saudi Arabia at the Venice Biennale in 2011. She describes this photograph of the Haram taken at night as follows: 'A look from above shows Mecca as a whirling molecules, of the universal energy, manifesting in this circle or eye of the holy mosque which expands to involve the whole city and the whole planet in its eye.'*

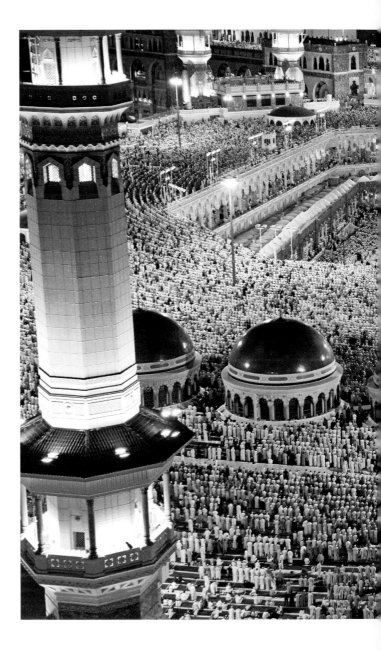

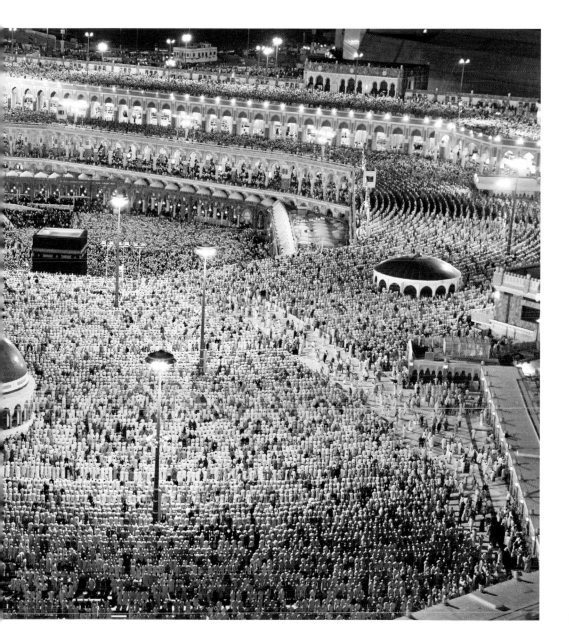

A manual for pilgrims, the Futuh al-Haramayn (Revelations of the Two Sanctuaries)

In the early sixteenth century Muhyi al-Din Lari (d. 1526) composed in Persian verse a guidebook for making the pilgrimage to Mecca which became extremely popular. A good number of manuscripts have survived, at least twelve of which have colophon inscriptions indicating that they were produced in Mecca itself and could have been acquired by pilgrims as souvenirs of their Hajj. All the known copies contain colourful illustrations which present stylized rather than strictly accurate representations of places of interest in and around the holy cities of Arabia, including particular locations where rituals specific to Hajj take place. On the following pages are illustrations from three different manuscripts of the Futuh al-Haramayn accompanied by relevant extracts from the poem (translated for this book by Muhammad Isa Waley).

Fig. 29
The sanctuary at Mecca and the rite of *tawaf*, from the Futuh al-Haramayn by Muhyi al-Din Lari (fol. 19b), copied by Ghulam Ali

Mecca, 1582
21.6 x 13.9 cm
Nasser D. Khalili Collection
of Islamic Art

54

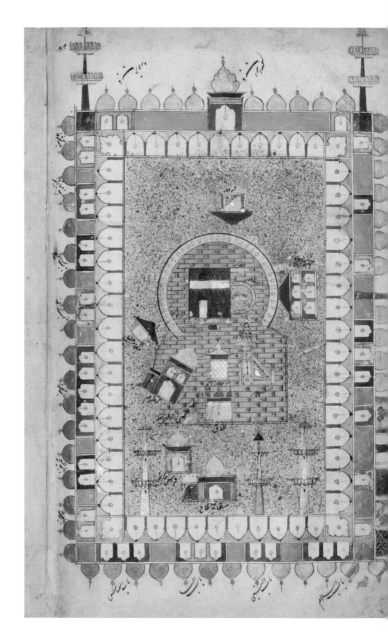

EXPRESSION OF THE AMAZEMENT AND WONDER THAT ARISE FROM BEING INSPIRED ON REALIZING THAT ONE HAS ARRIVED

What I have experienced from seeing that sight
is a mystery that I am unable to divulge.

My heart became drowned in the Ocean of Meeting;
I was lost to myself in the glory of Beauty.

It made me bewildered, amazed, stupefied;
the house of my being parted from its foundations!

Crying out, I made for the place of *tawaf*;
dancing, I came forward for my circumambulation.

His infinite generosity became manifest
as I planted a kiss upon the Black Stone –

revolving, circling, and full of presence
I became a moth, and He a luminous candle.

Fig. 30
The Mas'a (Place of Sa'i), from
the Futuh al-Haramayn by Muhyi
al-Din Lari (fol. 21a)

Mecca, 1582
25 x 17 cm
Nasser D. Khalili Collection
of Islamic Art

The mas'a *is the area where pilgrims
perform* sa'i, *running seven times
between the hills of Safa, marked
at the top right, and Marwa at*

THE WAY OF PERFORMING *SA'I*, AND ITS ETIQUETTE

You have gained your desire from the stage of *tawaf*.
Move on soon to the *mas'a* to perform the *sa'i*.

Turn away from the House to the Gate of Safa;
go to Safa and climb up the steps to the top.

See the arch of Safa, like the vault of the skies,
with troops of angels up above it in lines ...

Face towards the side holding His Black Stone,
back to the mount of His eternal generosity:

The mount of Safa its head raised up to the sky,
its height that of the sun's and moon's rising-points ...

Descend quickly, then head towards the *mas'a*;
come into the valley, without your head or feet.

The Messiah's feet will do the walking for you.
How could the wings of the angels reach your dust?

Start shuttling to and fro – such a coming and going
as gained for men that which angels never won ...

Marwa is to one side, Safa to another;
the performer of *sa'i* must be true to his word.

Fig. 31
Muzdalifa, from the Futuh
al-Haramayn by Muhyi al-Din-Lari
(fol. 29a)

Iran, 16th century
25 x 17 cm
British Library, London

At Muzdalifa the pilgrims pick up
the forty-nine stones that they will
need to stone the Jamarat pillars
representing 'the Satans'.

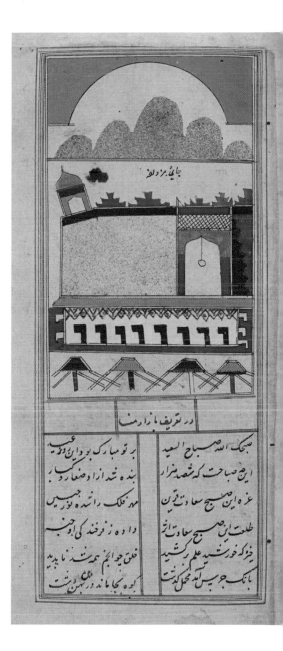

DESCRIPTION OF THE MULTITUDE AND CROWDING OF THE CARAVANS AT THE STOPPING-POINT OF THE SACRED MUSTERING-PLACE (*AL-MASH'AR AL-HARAM*)

This is Muzdalifa, the same territory
you passed through on the ninth day [of the month].

But [this time] its noble splendour catches the eye,
and it shows itself now in a different light.

Caravans for which Arafat had no space
will stay for the night at this stopping-place.

Tonight it is the oyster-shell for its pearl;
tonight it is the distinction for its star.

Egyptians and Syrians, on all sides,
[camp] in lines around it in deepest respect.

The expanse of this plain is filled, all night,
with colourful tents as far as you can see.

Like roses and tulips, the candles and lamps
make up meadows and gardens, one after another.

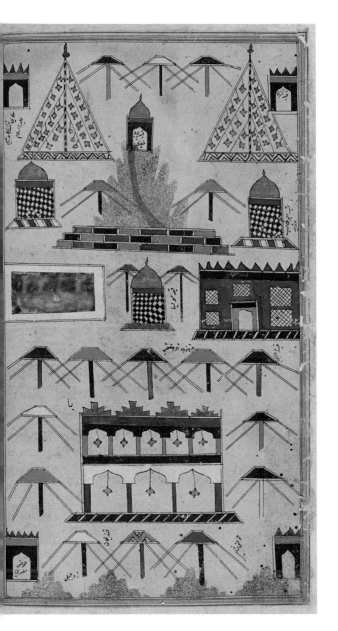

Fig. 32
The plain of Arafat, from the Futuh al-Haramayn by Muhyi al-Din Lari (fol. 27b)

Iran, 16th century
25 x 17 cm
British Library, London

The plain of Arafat, 14 km east of Mecca, is where the wuquf *(standing) takes place from noon until dusk on 9th of Dhu'l Hijja. It is the central rite of Hajj.*

A farsakh, more or less, from Muzdalifa
is an area empty as Non-being itself.

Its expanse is greater than the pilgrims' hearts –
each of whom is now absorbed in his own business.

Though it lies beyond the *haram* boundaries,
it is the gateway-place for all those caravans.

Enter this area, with full sincerity,
making your supplications, and behold ...

The mountain of which Arafat is the name
is more lofty than all other mountains are.

Its skirts are filled with the Compassion of God;
around it mankind and angels assemble.

Its shadow betokens the cool shade that God
provides in the courtyards of Paradise.

Though smaller in form than other mountains,
in meaning it is higher than all of them.

The valley of Mina, 5 km east of
Mecca, is where pilgrims camp
during Hajj. The Jamarat *or Satans*
are located here. The stoning of
these pillars is a rite of Hajj.

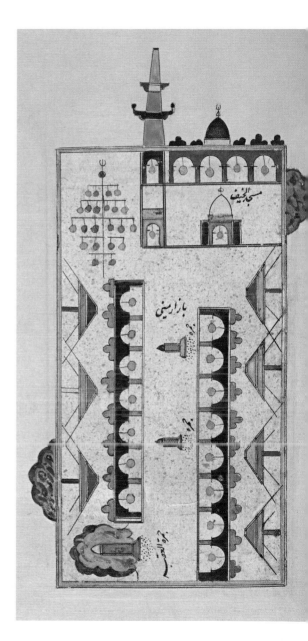

Best to leave Mina's market without delay,
before all its colours and scents trap your heart.

Make for the *jamra* with warlike mien;
approach it with your bag [*daman*] filled with stones.

Remember that line that is drawn up for battle;
with a stone in your raised hand, wage holy war [*jihad*].

The people who wield swords to fight for Islam
make the *takbir* their war cry, extinguishing self.

You likewise, after each stone that you cast,
should raise a *takbir* from your very soul.

Cast a stone at that *jamra* seven times,
inflicting hard blows on Azazil's [i.e. Satan's] face.

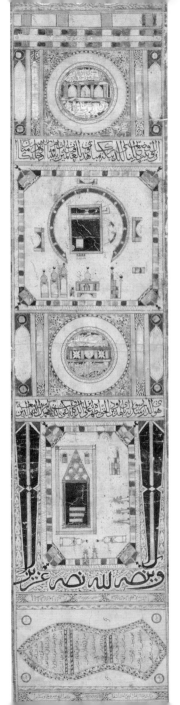

Fig. 34
Pilgrimage certificate (details),
dated 1433

Coloured inks and gold
on paper
212 x 28 cm
British Library, London

This remarkable document is a
complete Hajj certificate attesting
the Hajj of a certain Maymuna,
daughter of Abdallah al-Zardali, in
the year 1433. The details of her
Hajj and the indication that she
went from Mecca to Medina after
Hajj are in a section at the base of
the certificate (not shown). Reading
downwards, the scroll depicts the Hajj
pilgrimage sites. It starts with Mount
Arafat, followed by the Haram at
Mecca (detail opposite) with above,
in thuluth *script, verses from the*
Qur'an (3:96–7): 'The first House [of
worship] to be established for people
was the one at Mecca [spelled as
Bakka]. It is a blessed place, a source
of guidance for all people.' As usual in
such depictions, major features within
the sanctuary are labelled.

The hills of Safa and Marwa follow,
then the Prophet's mosque at Medina,
and finally a stylized image of the
*Prophet's sandal (*qadam al-Nabi*).*
The representation of the sandal
of the Prophet was regarded as
protective and the texts within this
section include specific instructions
on how the qadam al-Nabi *should*
be venerated: 'I rub the image of
the sandal of the Prophet over the
whiteness of my old age to seek
the Prophet's approval. It is not for
the love of the image that my heart
tires but for the love of the wearer
of the sandal.'

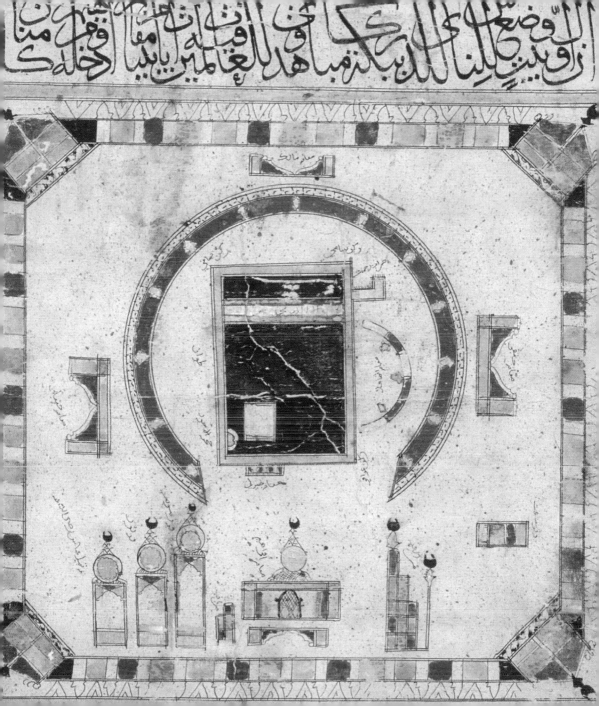

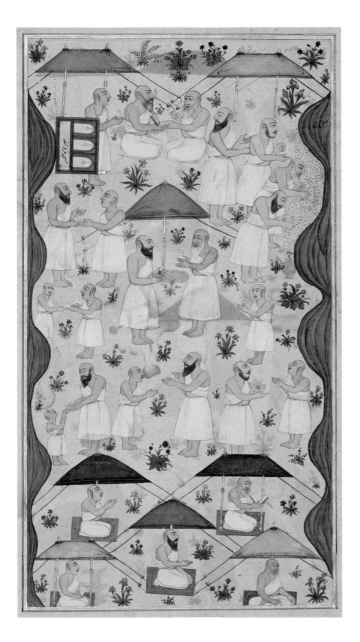

Fig. 35
**Pilgrims performing rites of Hajj,
from Anis al-Hujjaj (The Pilgrim's
Companion) by Safi ibn Vali (fol. 10a)**

India, possibly Gujarat, c.1677–80
Ink, watercolour and gold on paper
33 x 23.2 cm
Nasser D. Khalili Collection of Islamic Art

*This painting is a unique depiction of the
rites of Hajj. Male pilgrims are shown
encamped at Muzdalifa. A group of them,
on the right, can be seen picking up
the stones they will use to throw at the
Jamarat, the pillars at Mina symbolizing the
three places where Satan tried to dissuade
Abraham from making the supreme sacrifice
of his son. The pilgrims, and a small boy
on the left are in* ihram. *Some, beneath
colourful tents, are either engaged in
conversation or kneeling in prayer with
outstretched hands.*

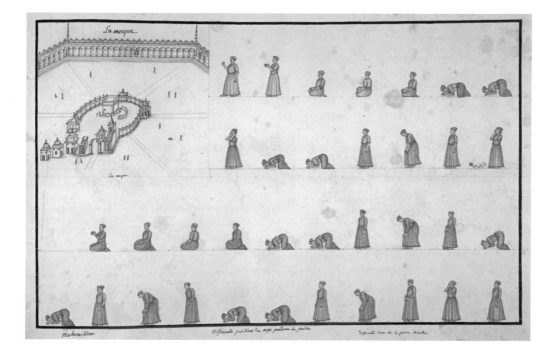

Fig. 36
**People at prayer, from the
Gentil Album**

Faizabad, India, c.1774
Watercolour on paper
37 x 53.5 cm
Victoria and Albert Museum, London

*This watercolour belongs to a genre
known as 'Company School', produced
by Indian artists for Europeans living
in the Indian subcontinent in a fusion
of traditional Indian and European*

*artistic styles. The painting was made
to demonstrate the various postures
assumed by Muslims in their ritual
prayers. The worshippers are dressed
in Mughal costume and face the
sanctuary at Mecca, which is simply
drawn topographically in black. This
is part of an album of fifty-eight
Company paintings commissioned by
French infantry colonel Jean-Baptiste-
Joseph Gentil (1726–99), who served
under Shuja' al-Daula, ruler of Awadh
between 1774 and 1786.*

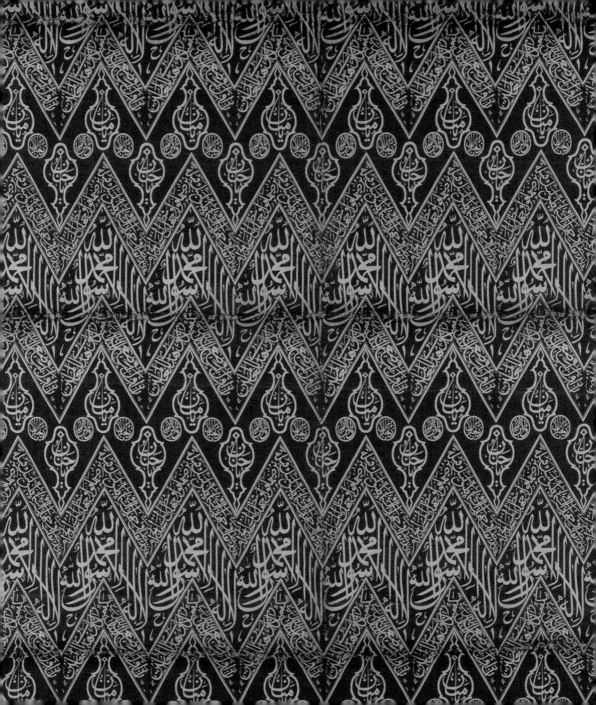

Chapter 5

Textiles for Mecca and Medina

The covering was placed on the venerated roof above the Ka'ba ... to the beholder the Ka'ba then presented the most comely sight, appearing as an unveiled bride in the finest silk brocade ...

Ibn Jubayr (1145–1217)

Fig. 37
Section from an internal *kiswa* **of the Ka'ba**

*c.*1935
Silk lampas
138 x 82 cm
Nasser D. Khalili Collection
of Islamic Art

This red kiswa section is similar in style to one presented to the Ka'ba by al-Sayyid Tahir Sayf al-Din, an Indian dignitary, on 16 April 1936. Due to incidents occurring between 1924 and 1928, Egypt did not send any kiswas or associated textiles to Mecca at this time. As a result the Sa'udi king Abd al-Aziz ordered alternatives to be made in Mecca – probably by Indian craftsmen brought in specially from India. Previously, the internal kiswas were made in Turkey and were only changed on the accession of a new sultan. The design follows an established tradition going back at least as far as the sixteenth century. The bold inscriptions within the chevrons are a repetition of the Profession of Faith, with Qur'anic verses in smaller script together with three of the 'Names of God' repeated in the flask-shaped medallions.

The practice of clothing the Ka'ba with textiles has pre-Islamic origins. According to legend, the Yemeni king Tubba As'ad Kamil first covered the Ka'ba with a special cloth from Yemen in about AD 400. This ritual act was part of an ancient tradition of veiling sacred places.

These sumptuous textiles were renewed by the rulers who had authority over the holy places. Most were made in Egypt until the twentieth century, but they are now made in Mecca. The main textile is the overall covering (*kiswa*), which in early Islam was in a variety of colours but was changed to black in the Abbasid period (750–1258). Placed at about two-thirds of the height of the *kiswa* is a belt (*hizam*). Over the door is an embroidered curtain (*sitara*). Inside the Ka'ba were other textiles: a curtain to the door leading to the roof, known as the Bab al-Tawba (the Door of Repentance), and red textiles with chevron designs on the inside walls, generally made in Turkey. A cover was also made for the Maqam Ibrahim, the place where Abraham is believed to have stood when building the Ka'ba. Once replaced, the textiles would be cut up and given as gifts, placed on tombs or turned into special garments. Textiles were also made for the Prophet's mosque in Medina.

Fig. 38
Curtain (*sitara*) to the door
of the Ka'ba

Cairo, dated 1846–7
Silver and silver-gilt wire on black
silk with red silk appliqués
550 x 275 cm
Nasser D. Khalili Collection
of Islamic Art

This sumptuous and heavily
embroidered textile (known as
sitara) *was placed over the door that*
marked the entrance to the Ka'ba.
It is lavishly decorated with bold
arrangements of inscriptions from
the Qur'an and at the base with a
band of palm fronds. In the central
black rectangle (detail opposite) is
*the dedication of al-*burda al-sharifa,
the noble cloak, by the Ottoman
sultan Abd al-Majid I (1839–61).

St John Philby, the English traveller
and Muslim, witnessed the changing
of the textiles in 1931, by which time
they were being made in Mecca:
'And even as I watched, the great
new sheet of drapery … was let
down with a rush to bury temporarily
under its skirt the crowd of pilgrims
pressing forward with prayerful
invocations … When the four pieces
of kiswa *are in place, they are duly*
joined up by workmen lowered
from the roof … the last item of
the proceeding being the filling of
the gap of the kiswa *over the Ka'ba*
doorway by the rich burqa, *or veil of*
silk and gold-lettered arabesque.'

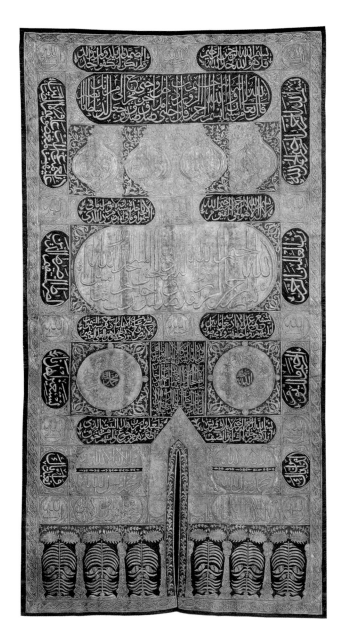

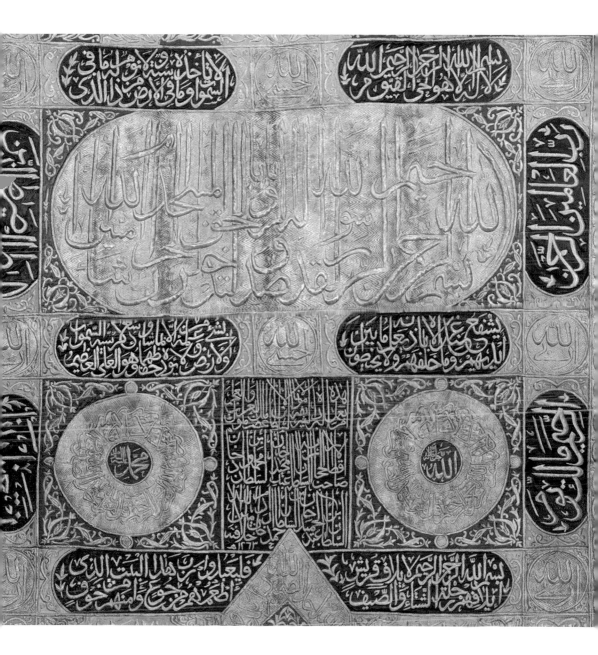

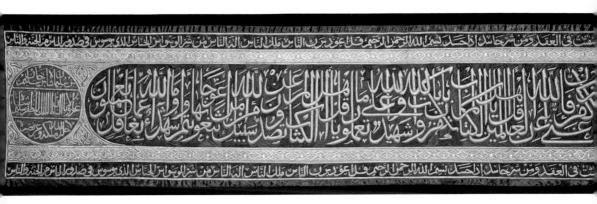

Fig. 39
Belt (*hizam*)

Egypt, 1566–74
Silk embroidered with silver
and silver-gilt wire
95 x 742 cm
Nasser D. Khalili Collection of
Islamic Art

*Heavily embroidered with bold
inscriptions clearly designed by an
accomplished calligrapher, this belt
for the Ka'ba was made during the
reign of the Ottoman sultan Selim II
(1566–74), as indicated in the red
roundels bearing his name. Some
parts of the belt may have been
made later. The central inscription
in the monumental thuluth script
contains the verses identifying the
Ka'ba at Mecca as 'the first house
[of worship] appointed for mankind
(Qur'an 3:96–9), with other verses
in smaller script above and below. In
the nineteenth century the Egyptian
factory where the textiles were made
was in the quarter of Kharanfash. In
the 1830s Edward Lane witnessed
the parading of the sacred textiles:*

*'This and almost every shop ... were
crowded with persons attracted
by the desire of witnessing the
procession. About two hours after
sunrise the four portions which
form each side of the "Kisweh"
were borne past ... each of the four
pieces placed upon an ass with
the rope with which they are to be
attached ... after an interval came
about twenty men bearing on their
shoulders a long frame of wood upon
which was extended one quarter
of the "Hezam" [belt]. The Hezam
is in four pieces which when sewed
together to the Kisweh form one
continuous band to surround the
Kaabeh entirely ...'*

68

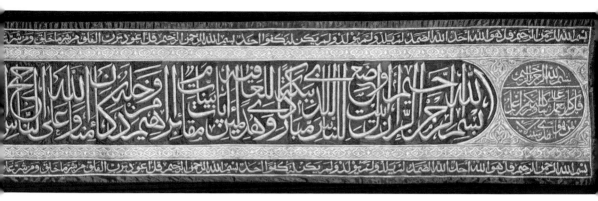

Fig. 40
Panel

Egypt, 19th century
Black silk with red silk appliqués,
embroidered in silver and silver-
gilt wire over cotton and silk
thread padding
92 x 92 cm
Nasser D. Khalili Collection
of Islamic Art

Square embroidered panels were
placed on the kiswa at the four
corners of the Ka'ba, below the
belt (hizam). They are known as
samadiyya *on account of the words*
from the Surat al-Ikhlas (Qur'an
chapter 112), Allahu al-Samad,
'God the Eternal', in the embroidered
text disposed in a circle.

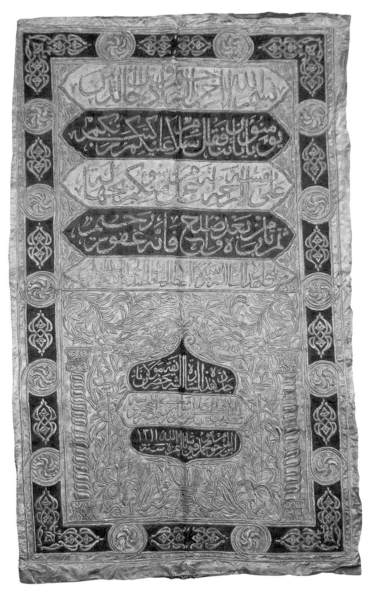

Fig. 41
Curtain for the Bab al-Tawba

Egypt, dated 1893–4
Green silk with red and gold
silk appliqués, embroidered in
silver and silver-gilt wire over
cotton and silk thread padding
265 x 158 cm
Nasser D. Khalili Collection
of Islamic Art

In addition to the other textiles of
the Ka'ba, in the mid-nineteenth
century curtains began to be made
for the interior door leading to the
roof, known as the Bab al-Tawba
(Door of Repentance). The inscription
on this example indicates that it
was commissioned by the Ottoman
sultan Abd al-Hamid II (1876–1909)
and presented by Abbas Hilmi II,
the last Khedive of Ottoman Egypt
(1874–1931), who went on Hajj
in 1909.

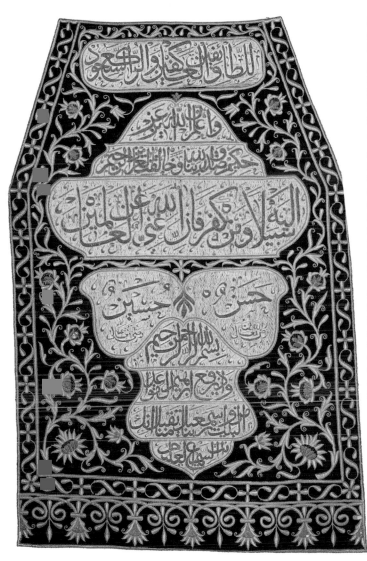

Fig. 42
Section of cover for the
Maqam Ibrahim

Egypt, late 19th century
Embroidered silk
200 x 125 cm
Nasser D. Khalili Collection
of Islamic Art

The Maqam Ibrahim, where
Abraham is believed to have
stood when he rebuilt the Ka'ba,
traditionally had its own textile
covering (kiswa) as well. An
example in the Topkapi Palace in
Istanbul dates from 1682. Like
the other textiles here, they were
mainly produced in Egypt. They
were composed of four panels – this
example comes from the last section.
The fabric is a piece of the kiswa
of the Ka'ba. Embroidered over it
are floral designs and verses from
chapters 2 and 3 of the Qur'an,
al-Baqara and Al Imran. In panels
all the way around would have been
the names of the Prophet's family,
ending in this section with those
of his grandchildren, Hasan and
Husayn.

Fig. 43
Waistcoat

c. 18th–19th century
Silk lampas
Museum of Islamic Art
Malaysia, Kuala Lumpur

After the textiles of the Ka'ba and those of Medina had been replaced, the old ones were generally cut up and some were made into garments. This waistcoat is in Malay style and was fashioned from a piece of the internal kiswa of the Ka'ba probably made at Bursa in Turkey. Stylistic features such as the medallions shaped like hanging lamps between the chevron designs represent a phase in the evolution of these textiles datable to c.1800 (a later example in this style is fig. 37).

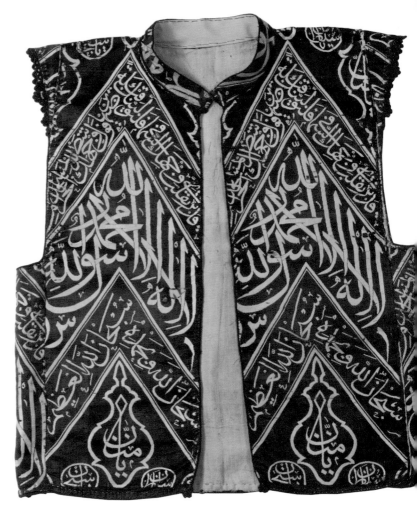

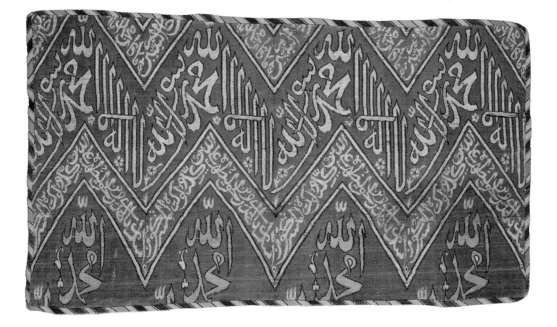

Fig. 44
Section of textile for the mosque of the Prophet in Medina

Ottoman Turkey, 17th century
Silk lampas
39 x 65 cm
Victoria and Albert Museum,
London

This beautiful fragment in dark green silk with woven inscriptions in white was likely to have covered the Prophet's tomb at one time. Chevron designs representing these textiles can be seen in manuscripts and tiles. It is clear that this piece was greatly treasured as it was carefully lined and edged.

Fig. 45
Textile for the Prophet's mosque at Medina

Probably Egypt, 1803
Silk with appliqués, gold and
silver-gilt wire
289 x 136 cm
Nasser D. Khalili Collection of
Islamic Art

*Sumptuous textiles were also made
as gifts for the Haram (sanctuary)
at Medina, to be placed in specific
locations within it. This example is
likely to have been for a* mihrab *or
prayer niche. In design it is a classic
representation of the* mihrab *within
a mosque, which often contains
a hanging lamp. The lamp is an
allusion to the Light Verse (Qur'an
24:35) in which God is described
as the light of the heavens and
earth, and that light is likened to a
niche containing a lamp within a
glass, 'as it were a glittering star'.
Ottoman candlesticks stand at either
side of the lamp, with long candles
topped by tulip-like flames. There
are elegantly inscribed verses from
the Qur'an at the top and around
the sides. These include 49:3 (al-
Hujurat): 'Those that lower their
voice in the presence of the Prophet,
their hearts has God tested for piety,
for them is forgiveness and a great
reward.'*

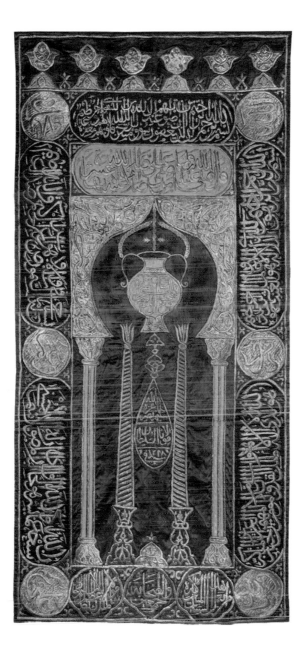

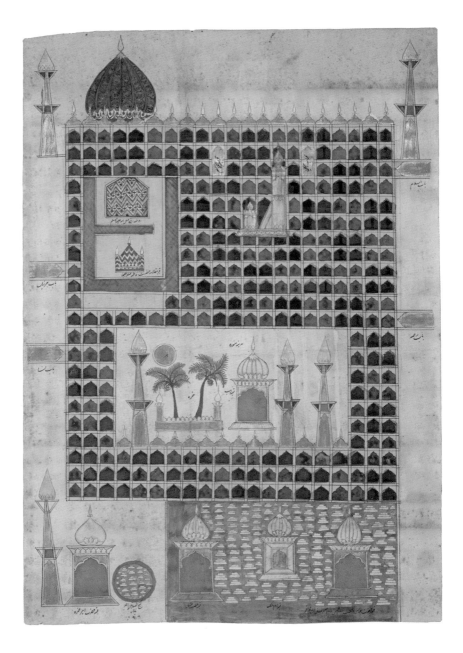

Chapter 6

Medina: City of the Prophet

The long line of camels ... and the pilgrims wait-
ing eagerly to catch their first sight of the house
of their beloved messenger of Allah caused a
strange welling up of emotions inside me. Tears
came into my eyes. I was reminded of my parents
and other relatives who had traveled like this
long ago to visit the holy sites of Medina.

Amir Ahmad Alawi, 1929

Fig. 46
View of the sanctuary at Medina,
from a Hajj certificate

Probably Mecca, 17th–18th century
Opaque watercolour, ink, silver
and gold on paper
65 x 46.6 cm
Nasser D. Khalili Collection of
Islamic Art

This painting was once part of a
Hajj certificate (fig. 23) that was
probably the work of an Indian
artist in Mecca. The tomb of the
Prophet with its green dome is on
the upper left and below is the
cenotaph covered with the chevron-
patterned green and white textile.
In contrast to the painting from the
Dala'il al-Khayrat and the Medina
tile (figs 47 and 48), the colonnades
within the courtyard have here been
filled in with green and red arches.
In the centre is the tomb of the
Prophet's daughter Fatima with the
characteristic palm trees that she
planted in her garden.

Medina is known in Arabic as *Al Madinat al-Munawarra*, 'the Illuminated City'. Its importance lies in the fact that it was to here that the Prophet Muhammad migrated in 622 (the first year of the Islamic calendar). He built the original mosque next to his house. Although visiting Medina is not officially a part of Hajj, most pilgrims will go there before or after it. The Haram, or mosque of the Prophet, contains his tomb as well as those of his friends and first successors, Abu Bakr al-Siddiq and Umar ibn al-Khattab. For Muslims the Haram or sanctuary of Medina is the holiest site apart from that of Mecca. Depictions of it generally follow the same style of representation as those of the sanctuary at Mecca, and its key features are often labelled. They appear on tiles, Hajj certificates and illustrations for manuscripts of works such as the popular Dala'il al-Khayrat (Signs of Benediction) by the religious scholar and mystic Muhammad ibn Sulayman al-Jazuli (d. 1465) of Marrakesh in Morocco.

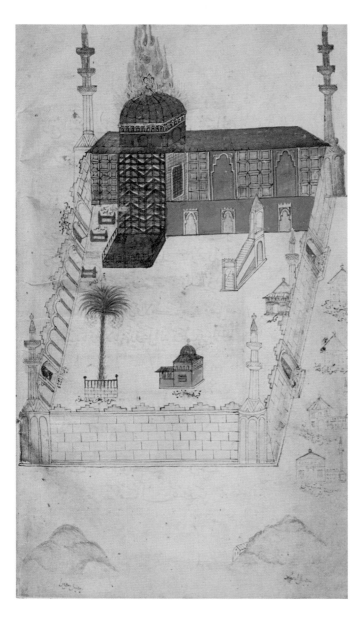

Fig. 47
The sanctuary at Medina, from the Dala'il al-Khayrat by al-Jazuli

Ottoman Turkey,
late 17th or 18th century
Ink, gold and opaque
watercolour on paper
20.4 x 12.3 cm
Nasser D. Khalili Collection of
Islamic Art

In this painting the sanctuary at Medina is shown in elevation, the domed tomb of the Prophet with its covering of chevron-patterned textiles surmounted by a fiery nimbus. The pulpit (minbar) of the Prophet is shown on the right. The tombs of the first two Caliphs (successors of the Prophet), Abu Bakr and Umar, and that of his daughter Fatima are marked, as are a number of the gates. Outside the walls are a group of mosques and below (to the north) the two mountains: Hira, near Mecca, where the Prophet received the first revelations in a cave; and Uhud, near Medina, scene of an epic battle between Muslims and the Meccan unbelievers.

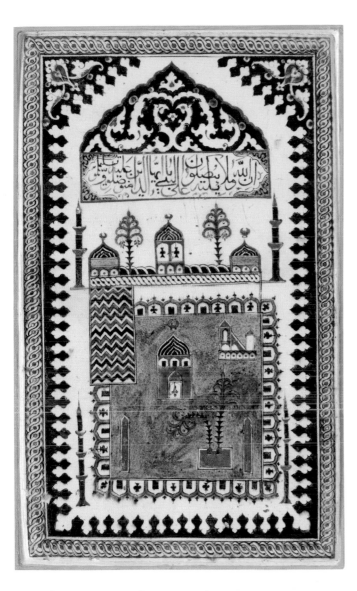

Fig. 48
Medina tile

Ottoman Turkey, mid-17th century
Stonepaste, underglaze painted
59.8 x 36 cm
Musée du Louvre, Paris

This tile is similar in style to the Mecca tile (fig. 16) and was made in Iznik or possibly Kütahya, towns in western Turkey. The lunette panel filled with Chinese cloud bands at the top contains a Qur'anic verse referring to the Prophet Muhammad: 'God and His angels send blessings on the Prophet. You who believe, invoke blessings and salutations to him in abundance' (Qur'an 33:56). The architectural details are simply and colourfully rendered. Within the blue courtyard is the pulpit (minbar) of the Prophet. His tomb and two others alongside may imply the presence of other mihrabs. To the left and a little below the pulpit stands a domed structure with a crescent-shaped finial, where the oil for the lamps was kept. The two rectangles on either side may represent lampstands for lighting the courtyard. Below is the garden of Fatima, daughter of the Prophet, which is always depicted with the two palm trees planted in his lifetime. The arcades are filled with hanging lamps, and slender minarets are at each corner.

Fig. 49
Candlestick

Probably Iraq, dated 1317–18
Brass inlaid with silver
45.7 x 36.8 cm
Benaki Museum, Athens

*Candlesticks were a popular gift to
the holy sanctuaries, particularly
in Medina. This example has a
fascinating history. It is dated and
signed by a craftsman called Ali ibn
Umar ibn Ibrahim al-Sankari who
was one of the last in a long line
of craftsmen associated with Mosul
in northern Iraq, an important and
influential centre of inlaid metalwork
in the medieval period. It was
probably made for a ruler of Mardin.*

*Included within the dense arabesque
designs and inscriptions are a series
of figures in arcades along the base
and neck of the candlestick. These
figures were subsequently scrubbed
out, perhaps by its next owner,
part of whose name features in an
inscription on the soffit stating that
the candlestick was given in waqf
(endowment) to the sanctuary at
Medina by Mirjan al-Sultani. Mirjan
can probably be identified as Mirjan
ibn Abdallah ibn Abdallah ibn Abd
al-Rahman al-Sultani al-Uljayti, a
vizier connected to the Il-Khanid
sultan Uljaytu, who is well known for
having constructed the Mirjaniyya
madrasa in Baghdad in 1357. As
this was now intended as a gift to
the sanctuary at Medina, the figures
would not have been appropriate:
figural representation was not
permissible on objects placed or
used in mosques.*

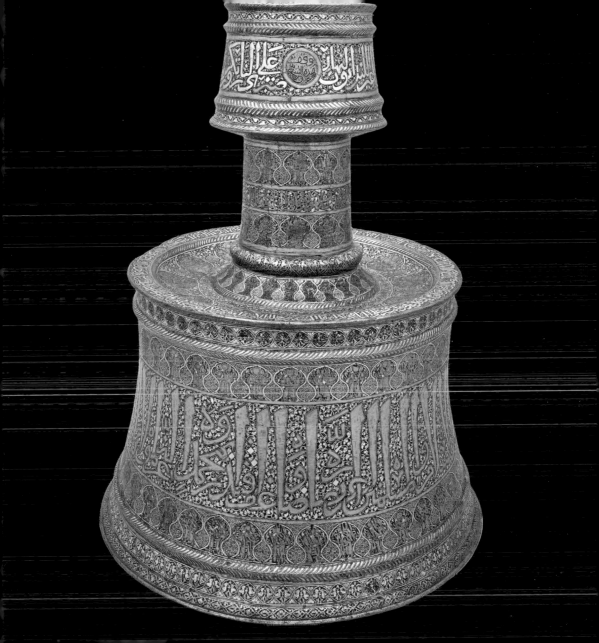

Fig. 50
Illustrations of Mecca and Medina

India, 18th–19th century
Watercolour, ink and gold
on laid Persian paper
15 x 10.2 cm and 15.2 x 10.5 cm
Private collection, London

This brilliantly coloured double page may once have formed part of a manuscript of the Dala'il Khayrat ('Guides to Goodness'), a highly popular devotional book in Arabic on the virtues of the Prophet Muhammad, with formulae invoking divine blessings upon him. It was written by Muhammad ibn Sulayman al-Jazuli (d. 1465), a Moroccan religious scholar and member of the Shadhiliyya Sufi order, and is often illustrated with depictions of the sanctuaries of Mecca and Medina. Other examples (see fig. 51) feature only the Prophet's mosque. The style of the painting, particularly in the forms and colours of the buildings, shows it to be the work of Indian artists, probably residing in Mecca (see fig. 18). As with other diagrammatic depictions, the key locations are labelled, in this case in Persian nasta'liq script.

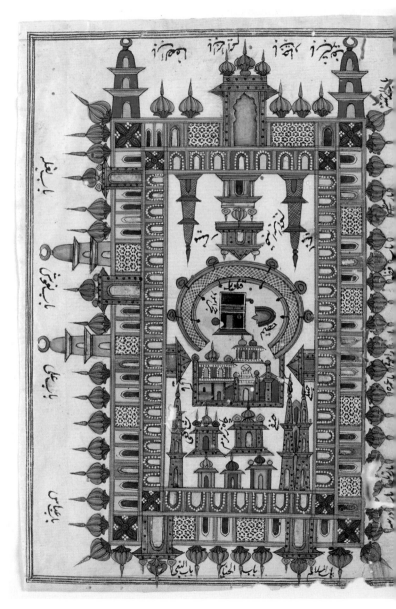

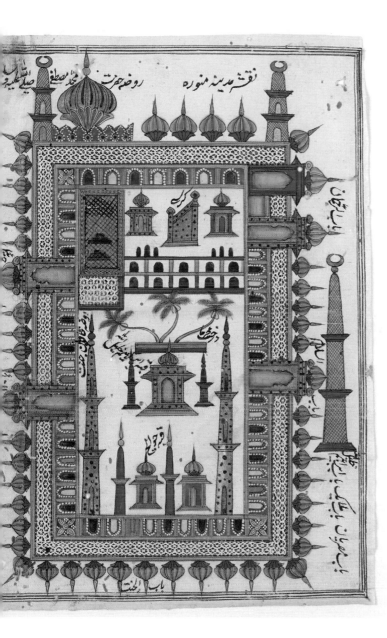

83

Fig. 51
Dala'il al-Khayrat, Muhammad ibn Sulayman al-Jazuli

Probably Patani, southern
Thailand, 19th century
16 x 10 cm
National Library of Malaysia,
Kuala Lumpur

This double page from a copy of Dala'il al-Khayrat is a detailed representation of the Prophet's mosque in Medina. Illustrated on the right is the Rawda *or garden. Under the arch are three oblong step-like shapes, which are described in the manuscript as follows: 'This is a description of the Blessed Garden [*Rawda*] in which the Messenger of God is buried, together with his two companions, Abu Bakr and Umar. This is related by Urwa ibn al-Zubayr: The Messenger of God was buried in the alcove [al-sahwa]. Abu Bakr was buried behind the Messenger of God, and Umar ibn al Khattab was buried near the feet of Abu Bakr.'*

On the left page is the minbar or pulpit on which the Prophet gave his sermons. It has triangles on either side and, as in the Rawda *illustration, a golden lamp hangs from an arch above. The illumination of these pages, dominated by brilliant red and gold, is remarkable. Elaborate floral designs, flags and flaming lamps exhibit an eclectic style drawing influences from Ottoman art as well as from local styles of South-east Asian Islamic art. Although this manuscript may have been made in the Malay world, it could also have been the work of a Patani artist in Mecca, where there was a large community of people from that region who had come for Hajj but stayed on in the Hijaz.*

85

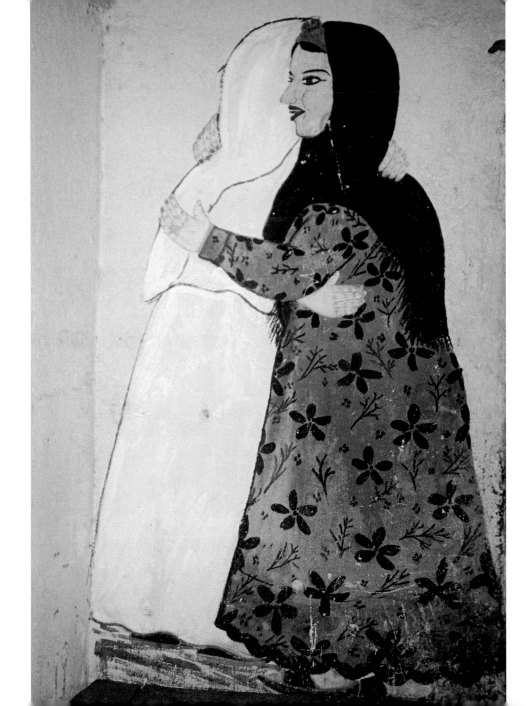

Chapter 7

The Homecoming

As Egyptian pilgrims start the last leg of their homeward journey, a mood of jubilation reigns through the land. Highways become crowded with overloaded cars and buses ... In country villages the home coming scene is still observed in the old-fashioned manner. Celebrants on horseback hold Hajj banners high above their heads as they gallop back and forth along dusty roads to the accompaniment of firearms being discharged into the air to announce the Hajjis' safe return.

Ann Parker, 1995

In the villages of Upper Egypt in particular there is a remarkable tradition of celebrating and commemorating Hajj through wall painting. The paintings appear on the exteriors of houses and in courtyards as well as inside and evoke the Hajj through images of the journey, once on camel and nowadays by plane or ship down the Red Sea to Jedda; of the holy sites such as the Ka'ba and the Prophet's mosque at Medina; and of the welcome that pilgrims receive on their return. To have performed Hajj is a source of pride, and to be called *hajji* or *hajja* is an honour. The paintings, which are generally executed with water-based paints or more rarely with oils, are often commissioned by the families of *hajjis*. The artists, who are rarely professional, are generally locals, and many come from families who have been making Hajj paintings for generations. Although the tradition of Hajj paintings seems to have started in the nineteenth century and proliferated in the twentieth, it has its roots in the wall painting traditions of Ancient Egypt.

Fig. 52
A *hajja* in white is embraced by a relative

Wall painting in Kom Ombo, north of Aswan
Photograph by Ann Parker

87

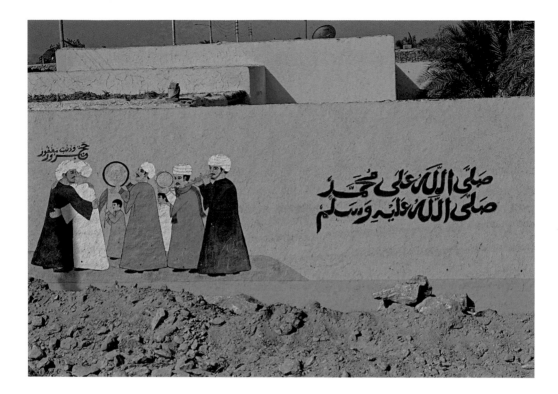

Fig. 53
Painted house in a village
between Luxor and Aswan

Photograph by Khaled Hafez,
2009

*Against a deep turquoise ground, a
hajji dressed in white is surrounded by
friends and relatives who wave flags
and celebrate with music. The two
lines of calligraphy on the right are
invocations of divine blessing upon the
Prophet Muhammad. On the left, above
the hajji, is the traditional phrase, 'Hajj
mabrur wa dhanab maghfur', 'May
the Hajj be abundantly rewarded [by*

*God] and sins forgiven'. The painting
and calligraphy are by Eid Yassin Ali.*

*Khaled Hafez has been recording the
paintings of Hajj artists for a number
of years. He is particularly drawn to the
popular culture of his native Egypt, and
his own work often draws and expands
upon the themes he finds, from Ancient
Egyptian to modern folk art.*

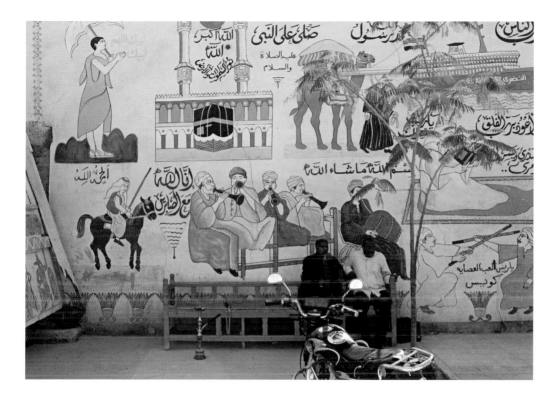

Fig. 54
Courtyard of a house

Photograph by Khaled Hafez, 2009

In this painting the references to Ancient Egyptian art are clear in the designs on the left side of the courtyard, and at the base of the main picture. The Hajj is beautifully evoked through vignettes of the rituals and the journey by camel and ship. At the top a pilgrim in ihram chants the talbiya, the special invocation made during Hajj, and faces the sanctuary he is about to enter. Below, the scene is one of joyous celebration, with men blowing the traditional trumpets echoed by the owner of the house who is seated on the bench. The inscriptions include verses from the Qur'an and benedictory phrases.

Fig. 55
Hajj **by Newsha Tavakolian, 2009**

Just before going on Hajj, the Iranian
artist Newsha Tavakolian texted her
friends, saying: 'Please forgive me if
I have done you wrong in any way.
I'm going on Hajj.' She explains,
'If a Muslim gets to go on the holy
pilgrimage to Mecca, he or she
should ask all family members and
friends for forgiveness, which I did
via text message after I was granted
a visa to take pictures there. Soon
after people came round bringing
essentials for the trip. My aunt
gave me prayer beads, my cousin
made me a white dress, which is the
customary color during the Hajj.'
On her return her family organized
a special traditional party, known as
Valima. *She recorded her pilgrimage*
in a series of evocative black-and-
white photographs. Her Hajj now
complete, her ihram *garment hangs*
in her flat, a powerful reminder of
her experience.

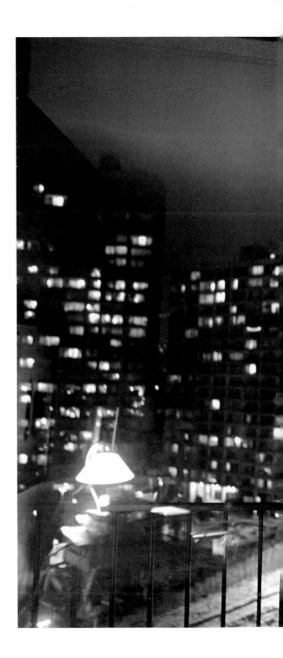

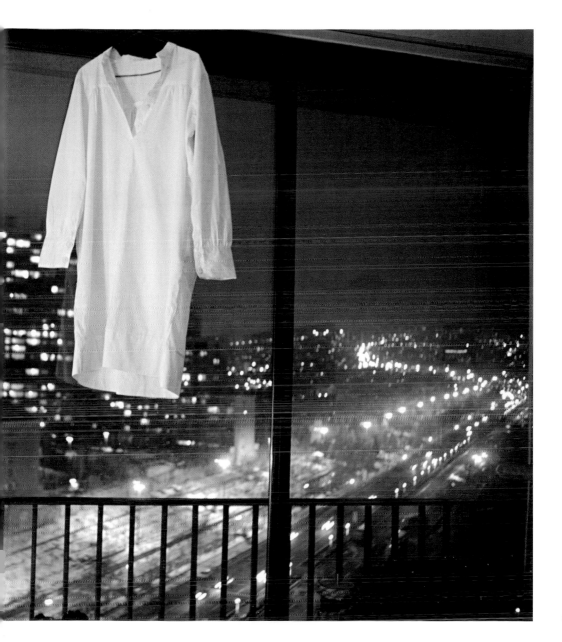

Fig. 56
Magnetism **by Ahmed Mater**

Photogravure I, 2011
British Museum, London

*Ahmed Mater is one of Saudi
Arabia's leading artists. He trained
as a doctor and studied art at
al-Meftaha Arts Village, part of
the King Fahd Cultural Centre,
under the patronage of HRH Prince
Khalid Al Faisal. He began his
series 'Magnetism' in 2007, first
showing it at the Venice Biennale
of 2009. This powerful evocation
of Hajj has developed into both an
installation of magnets and iron
filings and an accompanying series
of photogravures.*

*'When iron filings are put near a
dual-poled magnet, they gather
together forming a circle around
the magnet, but keep at a
distance according to the rules of
attraction.... This natural state is
similar to the emotional state which
prompts humans to gather together
around a centre. Though by nature
each individual is the centre of
himself, individuals like iron filings
are compelled to be part of larger
groups turned towards the centre.'*

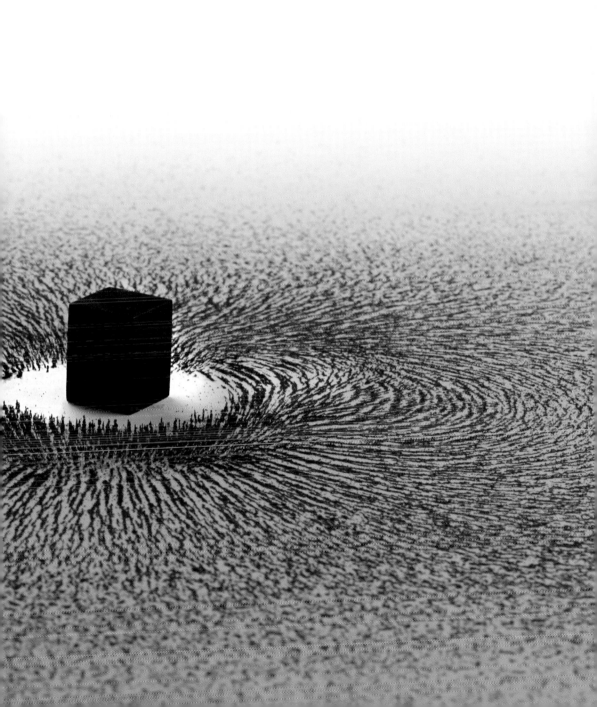

Glossary

Amir al-Hajj
Official leader of the Hajj caravan.

Arafat
Desert plain 14 km east of Mecca where pilgrims perform *wuquf*, known as the rite of standing, during Hajj. At its centre is the Mount of Mercy (Jabal al-Rahma).

Dhu'l Hijja
Twelfth (last) lunar month of the Muslim calendar, during which the Hajj takes place.

Eid al-Adha
Festival known as 'the feast of sacrifice' which marks the formal end of Hajj and continues for a further three days. It begins on the tenth day of the month of Dhu'l Hijja, and for pilgrims this takes place at Mina.

The five pillars of Islam
Five principles central to Muslim belief: the *shahada*, the Profession of Faith (there is no god but God, Muhammad is the Prophet of God); *salat*, the five daily prayers; *zakat*, the giving of alms; *ramadan*, fasting during the ninth month of the Muslim calendar; and the Hajj, the pilgrimage to Mecca.

Hajj
Pilgrimage to Mecca, one of the five pillars of Islam, which takes place between the eighth and twelfth days of the month of Hajj (Dhu'l Hijja), the last month of the Muslim lunar calendar. The title of *hajji* (male) or *hajja* (female) is given to Muslims who have performed Hajj.

hizam
Belt embroidered with verses from the Qur'an that is attached to the *kiswa* and goes all around the Ka'ba.

ihram
Rites of purification performed by pilgrims before entering the sacred territory of Mecca on pilgrimage. The term also applies to the clothing worn during Hajj and *umra*. For men this is two pieces of seamless white cloth, one fixed round the waist and the other covering the top of the body. Women's *ihram* consists of modest dress which can be any colour, although many choose white. The *ihram* is donned at specific places called *Miqat* which mark the boundaries of the sacred area of Mecca.

Jamarat
Three pillars in the valley of Mina close to Mecca that represent 'the Satans'. Over several days each pilgrim throws at them a total of forty-nine stones which they have earlier collected at Muzdalifa. This act of stoning commemorates the refusal of Abraham to be tempted by Satan.

Ka'ba
Cube-shaped structure at the centre of the *Masjid al-Haram*. Muslims believe that it was first built by Adam and then rebuilt by Abraham and his son Ishmael (in Arabic, Ibrahim and Isma'il). Wherever they are in the world, Muslims face the Ka'ba when they pray.

kiswa
Literally meaning robe; the outer black cloth placed over the Ka'ba that is replaced every year during Hajj.

mahmal
Fabric-covered palanquin carried on a camel that was sent every year with the official Hajj caravan to Mecca.

Maqam Ibrahim
Place where Abraham stood in prayer or, according to some traditions, where he stood when rebuilding the Ka'ba. It is marked by a small structure inside the Haram.

Marwa
One of two hills within the Haram in Mecca (the other is Safa), about 365 metres apart, between which Ishmael's mother Hagar is said to have run seven times in her desperate search for water. *Sa'i* is the Hajj rite representing Hagar's action.

mas'a
Course within the Haram in Mecca between the hills of Marwa and Safa along which the rite of *sa'i* is performed.

Masjid al-Haram, or Haram
Holy sanctuary at Mecca, consisting of the walled court of the Great Mosque (*al-Haram al-Sharif*, the Noble Sanctuary) within which are a number of sacred structures including the Maqam Ibrahim and the well of Zamzam. The term can also refer to the whole of Mecca.

mihrab
Niche within a mosque which faces Mecca.

Mina
Location a few kilometres east of Mecca where pilgrims camp overnight on their way to Arafat during Hajj.

minbar
Pulpit, where in depictions of the sanctuary at Medina the Prophet Muhammad stood to give his sermons.

Miqat
Five stations in a radius bordering the sacred territory of Mecca, where pilgrims purify themselves and put on the *ihram* before going on Hajj or *umra*.

mutawwif
Guide, often from a local Meccan family, who helps pilgrims perform the rituals of Hajj.

Muzdalifa
Location, nearly 6.5 km from the plain of Arafat, where pilgrims pick up the forty-nine stones they will need to throw at the *Jamarat*.

qibla
Direction of Mecca.

Safa
One of two hills within the Haram in Mecca (the other is Marwa), about 365 metres apart, between which Ishmael's mother Hagar is said to have run seven times in her desperate search for water. *Sa'i* is the Hajj rite representing Hagar's action.

sa'i
Rite that takes place during Hajj between the hills of Safa and Marwa, representing Hagar's frantic efforts to find water for her son Ishmael after Abraham left them in the desert. The running comprises seven ritual laps.

salat
Five ritual daily prayers, one of the five pillars of Islam.

sitara
Door curtain of the Ka'ba, sometimes also known as *burqu'*.

Sürre
Meaning purse, the name given to the Hajj caravan to Mecca during the Ottoman era.

talbiya
Prayer chanted during Hajj or *umra*, also known as *labbayka*. The first words are: '*Labbayk allahumma labbayk*', 'Here I am, Lord, responding to Your call' (to perform the pilgrimage).

tawaf
Ritual circumambulation that is performed anti-clockwise seven times around the Ka'ba.

tughra
Elaborate monogram representing the signature of the Ottoman sultan.

umra 'Minor' or 'lesser' pilgrimage that can be performed at any time of year and involves only the rituals of *tawaf* and *sa'i*.

wuquf
Rite of standing together at Arafat. This vigil takes place from noon to sunset on the ninth day of Dhu'l Hijja and is a high point of Hajj.

Zamzam
Well that miraculously appeared when Hagar was searching for water in the desert. Some traditions say it happened when her child Ishmael kicked his heel in the sand. The well is situated within the sanctuary at Mecca. Pilgrims often take Zamzam water home with them as a souvenir of Hajj.

Further Reading

Abdel Haleem, M.A.S. (trans.) 2005, *The Qur'an*, Oxford

Al Faisal, R. 2009, *Hajj*, Reading

Al-Qu'aiti, S.G. 2007, *The Holy Cities, the Pilgrimage, and the World of Islam*, Louisville

Barber, P. (ed.) 2005, *The Map Book*, London

Barnes, R. and Branfoot, C. (eds) 2006, *Pilgrimage: The sacred journey*, Oxford

Bayhan, N. (ed.) 2008, *Imperial Surre*, Istanbul

Bennett, J. (ed.) 2006, *Crescent Moon: Islamic art and civilisation in Southeast Asia*, Adelaide

Booth-Clibborn, E. (ed.) 2010, *Ahmed Mater*, London

Ettinghausen, R. 1962, *Arab Painting*, New York

Faroqhi, S. 1994, *Pilgrims and Sultans: The Hajj under the Ottomans*, London

Ibn Battuta, ed. and trans. H.A.R. Gibb 1956-71, *The Travels of Ibn Battuta A.D. 1325-1354*, 4 vols, Cambridge

al-Jazuli, Abu Abd Allah, trans. A.H. Rosowsky 2006, *Guide to Goodness (Dala'il al- Khayrat)*, Lahore

King, D.A. 1999, *World-Maps for Finding the Direction and Distance to Mecca: Innovation and tradition in Islamic science*, Leiden

Kioumgi, F. and Graham, R. 2009, *A Photographer on the Hajj: The Travels of Muhammad Ali Effendi Sa'udi (1904/1908)*, Cairo and New York

Maddison, F. and Savage-Smith, E. (eds) 1997, *Science, Tools and Magic (The Nasser D. Khalili Collection of Islamic Art)*, 2 vols, London

Parker, A. and Neal, A. 1995, *Hajj Paintings: Folk art of the Great Pilgrimage*, Washington, DC

Paths for Princes 2008, *Masterpieces from the Aga Khan Museum Collection*, Geneva

Pearson, N.M. 1994, *Pilgrimage to Mecca: The Indian experience, 1500-1800*, Princeton

Peters, F.E. 1994, *The Hajj: The Muslim pilgrimage to Mecca and the Holy Places*, Princeton

Peters, F.E. 1994, *Mecca: A literary history of the Muslim Holy Land*, Princeton

Porter, V. 1995, *Islamic Tiles*, London

Reeve, J. (ed.) 2007, *Sacred. Books of the Three Faiths: Judaism, Christianity, Islam*, London

Rogers, J.M. 2010, *The Arts of Islam. Masterpieces from the Khalili Collection*, London

Ruthven, M. with Nanji, A. 2004, *Historical Atlas of the Islamic World*, Oxford

Tavakolian, N. 2011, *The Fifth Pillar: The Hajj pilgrimage*, London

Titley, N. 1983, *Persian Miniature Painting*, London

Vernoit, S. 1997, *Occidentalism. Islamic Art in the 19th Century (The Nasser D. Khalili Collection of Islamic Art)*, London

Wolfe, M. 1997, *One Thousand Roads to Mecca: Ten centuries of travelers writing about the Muslim pilgrimage*, New York

Wright, E. 2009, *Islam. Faith, Art, Culture: Manuscripts from the Chester Beatty Library*, London

Illustration Credits